Hinda Schuman

DEAR SHIRLEY

Daylight

15 YEAR
ANNIVERSARY

Cofounders: Taj Forer and Michael Itkoff
Creative director: Ursula Damm
Copy editor: Elissa Rabellino

ISBN

Printed by Artron, China

Daylight Books
Email: info@daylightbooks.org
Web: www.daylightbooks.org

Preface

by Magdalena Solé

Honesty is rare enough. But when expressed through unflinching photographs, it becomes a unique artistic expression.

Hinda Schuman, in *A True Story* and *Dear Shirley*, reveals her 40-year journey and transformation in a series of images that are evocative, humorous, and intimate but always without judgment. By the end of the book, you are touched with a satisfaction that comes from a difficult trip that ends with everyone reasonably intact. There is also great humor in this approach, seeing styles and fashion that are worn and then jettisoned, and a sense of self seemingly hardwired as a youth but transformed over the course of a life unfolding. As singular events, what Hinda shares through her photographs is quite painful and obviously difficult in the moment. However, in hindsight when she arrives at authenticity, one feels that the experiences were clearly worth the suffering.

When Hinda first showed me the images for her book and we were about to develop a sequence, I became mesmerized by the clarity and directness by which she told the story of her closest relationships falling apart. Her loneliness hits you right between the eyes like a hurled chunk of loose rock. The weight of love lost carries heavily across her pages, only to be brightened by rare smiles. Nevertheless, Hinda is not self-referential; her protagonists are people who could be any of us. Her suffering resonates and becomes a ballad of love lost and found.

The juxtaposition of the black-and-white images of *Dear Shirley* with the color images in *A True Story* emphasizes the passage of time from the days of black-and-white to the Technicolor of the present. The artistry of her images resides in her unusual framing, her cut-off and cut-up faces, the rhythm of eyes open and closed. The tenderness in her nudes reveals the vulnerability of her subjects, and we become enthralled. We feel as if given a brief glance into a personal diary and a glimpse of private moments usually not revealed.

Experiencing the expanse of time and images is like hearing a great raconteur regale you with the events of a life lived fully and carefully, and that is a very rare treat.

Dear Shirley—a View from England

by Sunil Gupta

Dear Shirley,
I've gone from a married woman to a sexual minority in one embrace.
Love,
Hinda[1]

The history of lesbian and gay photography probably goes back as far as the origins of photography, but perhaps the notions of lesbian and gay as we know them in the 21st century are more recent. In their rush to categorize and define human behavior, the Victorians labeled "homosexuality" and then deemed it deviant, criminal, or morally abhorrent. Photography has played its part in this visual categorization throughout the mid-19th century; it said, this is what deviance looks like.

The gay artist and filmmaker Stuart Marshall wrote in 1990, "It has been forcefully argued by historians of sexuality such as Foucault, Weeks and Mort, that the sexual and social identities 'discovered' through this process were in fact constructed by it."[2] By the 1900s, it was thought that sexual "deviants" had recognizable human traits, and these became proof of their immoral and criminal behaviors.

The 20th century saw the proliferation of photography, and with it the private circulation of images for consumption by lesbians and gays that revealed home lives as well as fantasies and desires. However, it wasn't until the late 1960s and the sexual revolution, along with the civil rights movements, that such images were able to go public. By the beginning of the 1970s and after Stonewall, the demand for such "positive images" to counter the demonizing narratives became overwhelming. Of course, this went hand in hand with political demands for people to "come out" (and be counted). Photography and its dissemination became a preferred way to document being out. This led many people, including me, to pick up the camera to tell our stories, our way. A struggle ensued for control of representation.

I have known Hinda Schuman and been familiar with her work since 1988. We met on a panel titled very aptly "Partners in Crime" at the annual Society for Photographic Education Conference in Houston. It was organized by Doug Ischar and Kaucyila Brooke. It was my first experience of such an occasion, and the idea of discussing intimate details about one's sexuality early in the morning in a tower block hotel in front of a room full of strangers seemed

a little daunting. Photographers, with few exceptions, are naturally shy people, better behind the camera than in front of a microphone.

Listening to Hinda and watching the slides of *Dear Shirley* was an amazing experience on the panel. Panels can be dry and smart, but only rarely do they touch you emotionally. I was very taken with the work, its impressive honesty and simplicity of technique. Susan, one of the protagonists of the story, was also in Houston, so the work seemed even more present and real. It was something that I had been hoping to capture in my own work. Something not merely positive in the sense of happy, smiling lesbians, but something more human, complex, and compelling to counter the deviance narratives so prevalent at the time.

The sparse black-and-white imagery and the form of the diary also speak of an earlier, less complicated time before digital manipulation and alt truth. The narrative is presented simply as a set of frames almost straight out of the camera with just the text as a device to give the whole body of work a constructed look. It's worth noting that each frame is an extraordinary image—cinematic in its scope to present the mise en scène. What is passing for the equivalent of casual diary-like renditions is a collection of classic photographs, each one capable of standing in its own right.

The graphic format of the diary is both a feminine and feminist ploy to counter the patriarchal strategies of the Victorian documentarians and other outsider anthropological experts. This is not an objective account of the victimized wife falling prey to a marauding lesbian in the woods. It's a woman's very subjective account of a failing marriage and the beginnings of a new one, albeit an unrecognizable one at the time. It was the late 1970s and early 1980s, and lesbian and gay marriage seemed unthinkable.

The 1980s were first and foremost the decade of identity politics and the ensuing culture wars, and photography and film as representational media played a big part in them. Ever since I was an art student in England, I had struggled to see likenesses of me in art history. It became my mission to make some and get them placed in the art historical canon so that people who came after me should not find absolutely nothing when researching their local museum.

The Houston SPE panel led to an exhibition in London, at Camerawork.[3] It didn't seem strange that the work should immediately cross borders. The UK was in the throes of AIDS-related gay bashing and outright discriminatory pieces of anti-LGBT legislation, such as Clause 28, a notorious law that forbade local authorities to fund any activities (art, publishing, theater, etc.) that promoted lesbian and gay relationships as what it labeled "pretended" family relationships.

Hinda's coming-out story, while so locally detailed in its narrative with many references to the place (Vermont) and the weather (snow), still seems so universal in its scope. I have witnessed it exhibited in the US, in London, and in Delhi, where it was also seen at the Nigah Queer-Fest, and everywhere it has touched people in its clarity and depth of feeling around a very difficult subject: the unraveling of one family and creation of another.

Coming out is something nearly all LGBTI+ people must endure at some point in their lives, and for many people it can be a continuous, ongoing event as they encounter more and more people in their personal and professional lives. In some parts of the world, coming out is not an option yet, as the threats to physical and social security remain very real. At first glance, *Dear Shirley* is about the detail of the protagonists' lives as witnessed by Hinda, but the ever-present and unseen Shirley seems to stand in for society, so when we see Hinda being rejected at the conclusion, it's a judgment whose painful wrongfulness we share.

NOTES

1 Hinda Schuman, "Dear Shirley," *Stolen Glances: Lesbians Take Photographs*, eds. Tessa Boffin and Jean Fraser (London: Pandora, 1991).
2 Stuart Marshall, "Picturing Deviancy," *Ecstatic Antibodies: Resisting the AIDS Mythology*, eds. Tessa Boffin and Sunil Gupta (London: Rivers Oram, 1990).
3 *Partners in Crime*, exhibition featuring Kaucyila Brooke, Sunil Gupta, Doug Ischar, and Hinda Schuman, Camerawork London, 1989.

PART I
Dear Shirley

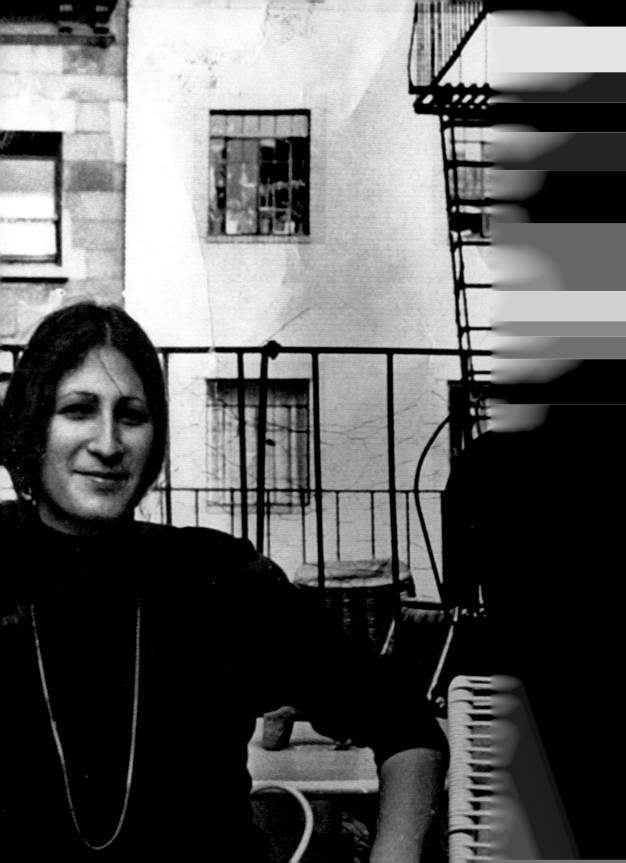

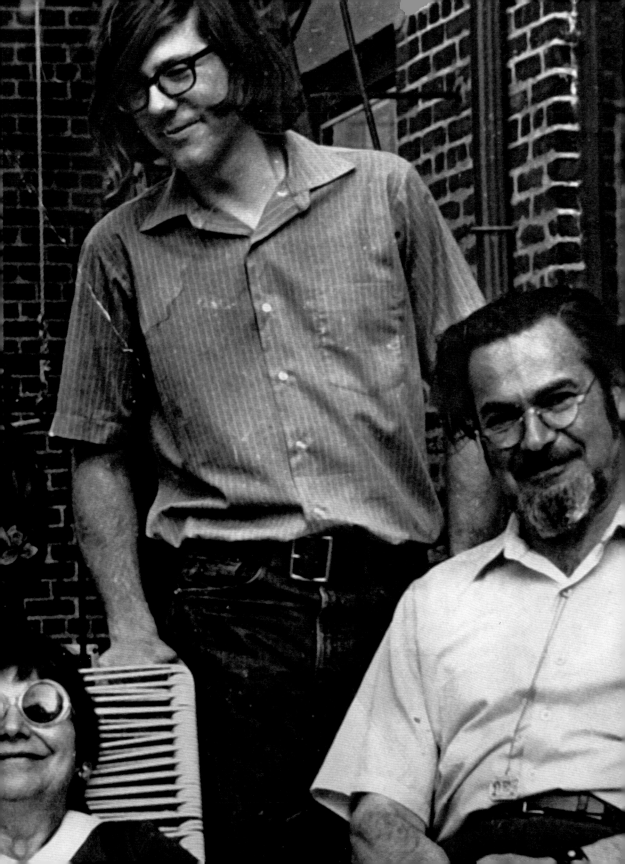

David and Sonia Schuman

announce the marriage

of their daughter

Hinda Ruth

to

Jeremy D. Birch

on October thirty-first

nineteen hundred and seventy-one

in

Putney, Vermont

8-14-78

Dear Shirley,

The confusion, anger and sadness are so
overwhelming that I feel I'd be better
off alone or dead. I feel I just go
deeper into hollow confusion.

Jeremy came home from Maine last night
and I sensed he wasn't so happy to see
me.

He feels he's fucked up. He reached out
to this woman, Nancy, and now he loves
this woman and she loves him. He feels
with that simple honesty he's hurt me.
He doesn't seem to acknowledge that
Nancy is a woman he sees as a patient.
He wants to know why he blows every
relationship.

If I didn't feel so hurt and so trauma-
tized by my husband being in love with
another woman there wouldn't be a problem.

I mean the guy works 32 hours a week.
Where is he supposed to go to meet girls?

Love,

Linda

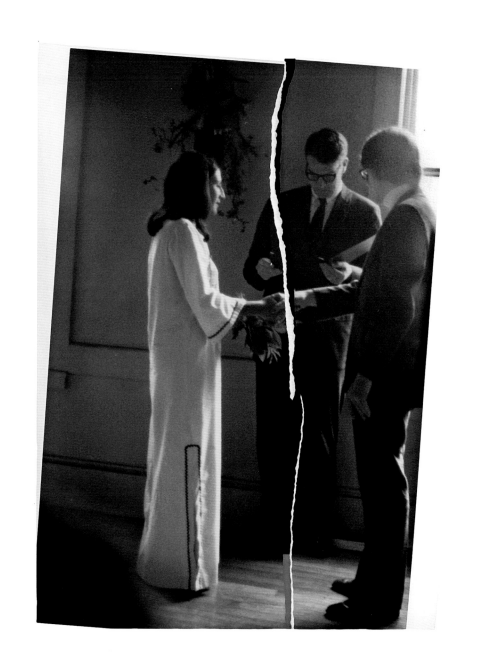

8-22-78

Dear Shirley,

A huge fight ensued. Jeremy told me that
Nancy feels sexually attracted to him.
(I think he likes it) (He denies it).

As Nancy starts to figure out her own life
she needs Jeremy less as a protector, problem
solver and wants him as an equal. Equality
is something he's never handled too well.
Nancy is leaving her husband.

I offered to find Nancy an apartment in
Hanoi.

Do I need this?

Love,

Hinda

9-10-78

Dear Shirley,

Jeremy is having an affair with Nancy.
The Subaru needs a new engine. I have a
pinched nerve in my leg. All of New York
City wants to come and see the foliage
and stay with us. I did two photo jobs
last week and both people called to express
dissatisfaction. Mats and Lisa's chimney
needs fixing and I can't locate the parts.
You un-invite me for the weekend-the one
thing that I'm looking forward to. And
my friend Ellen has found God and sleeps
with Jesus. You wonder why I'm up-tight?

Love,

Linda

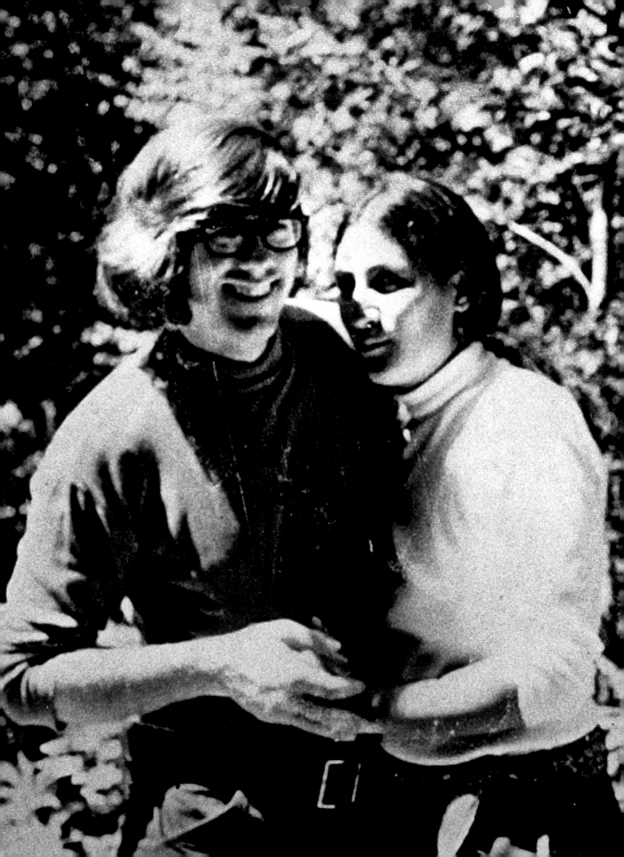

9-26-78

Dear Shirley,

Thursday passed calmly. Friday was lost.
We "discussed" Nancy all day. Our neighbor,
Betsy came for dinner and sided with Jeremy.
Nancy came to get her jewelery that Jeremy
had photographed for her. She's NOT a
terrible person. I just wish 1) she didn't
have so much power over me. 2) she'd mangle
her head in her truck's carburator.

I'll arrive Friday around 4:00. I have
a key.

Love,
HINDA

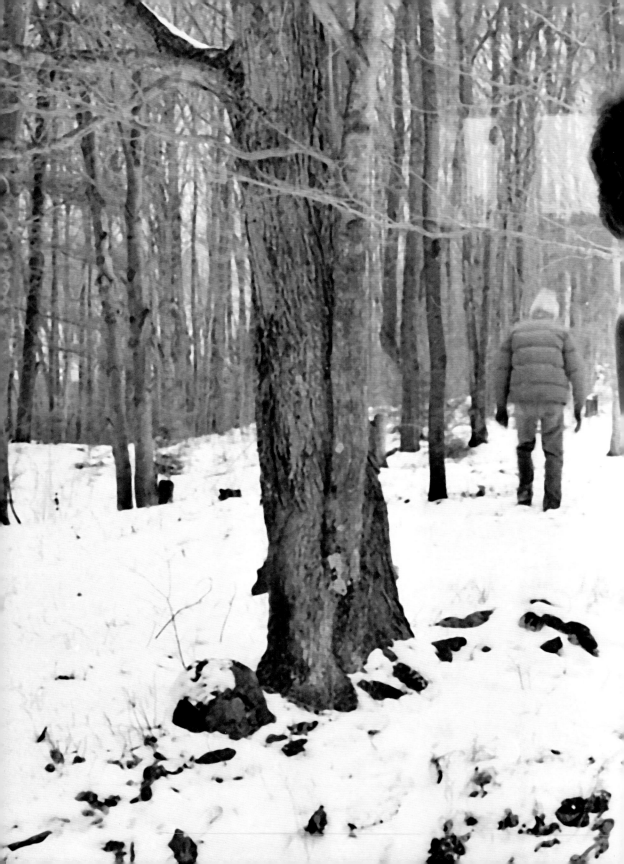

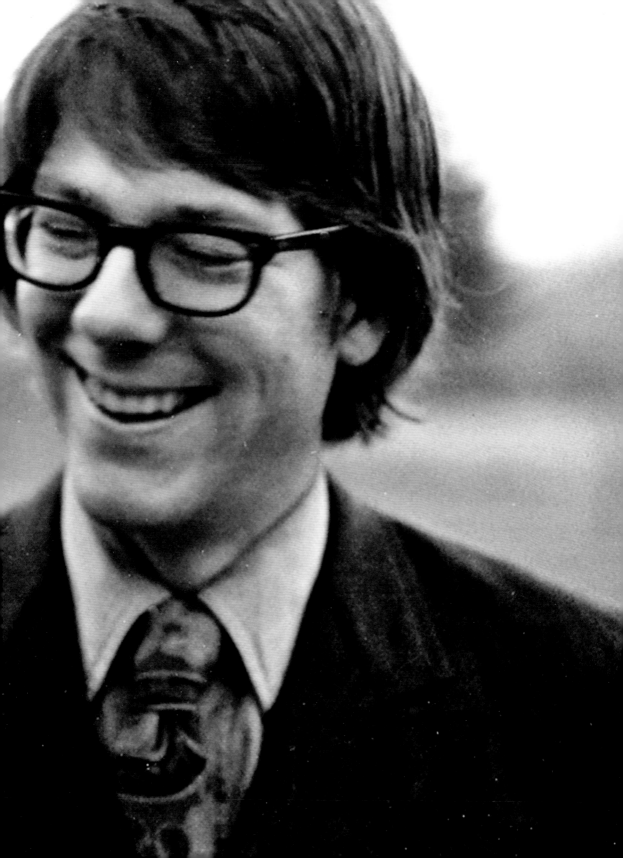

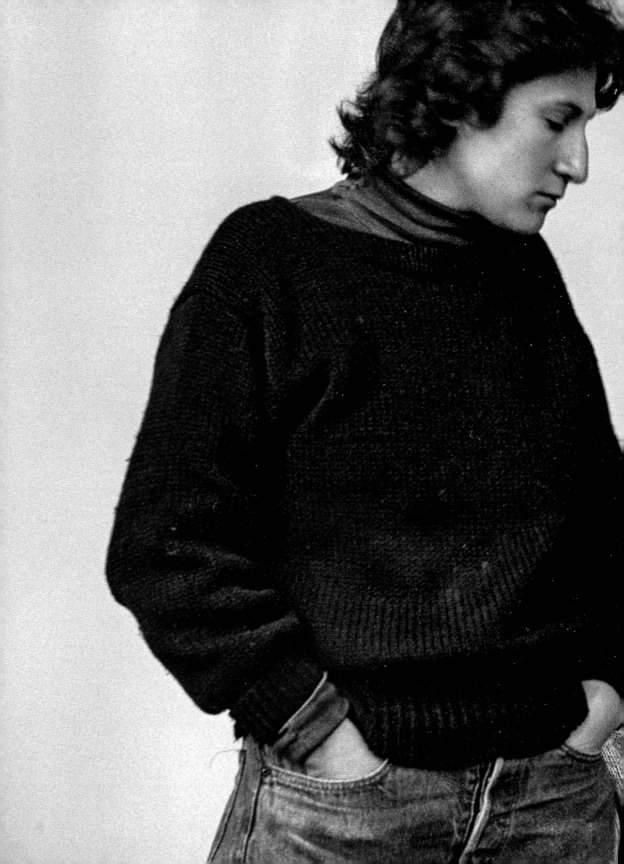

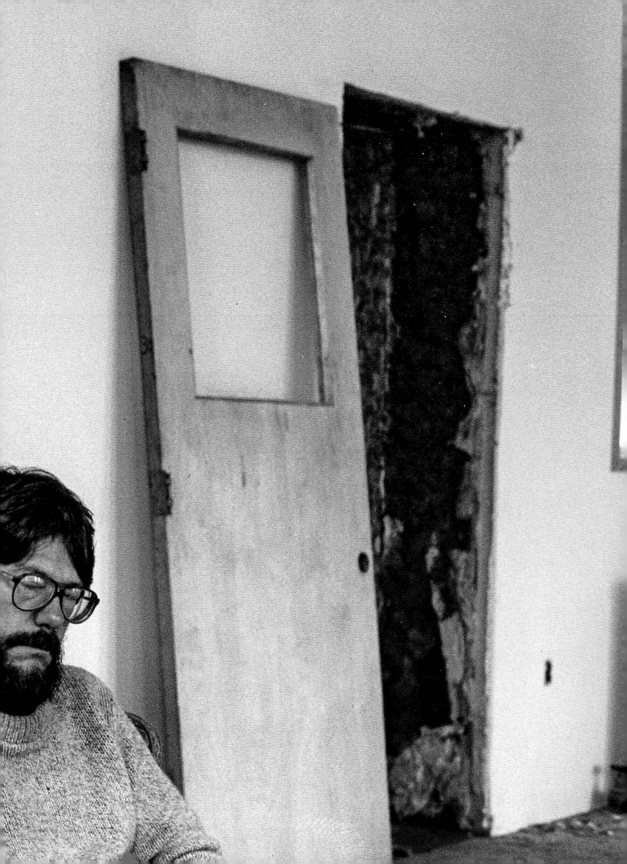

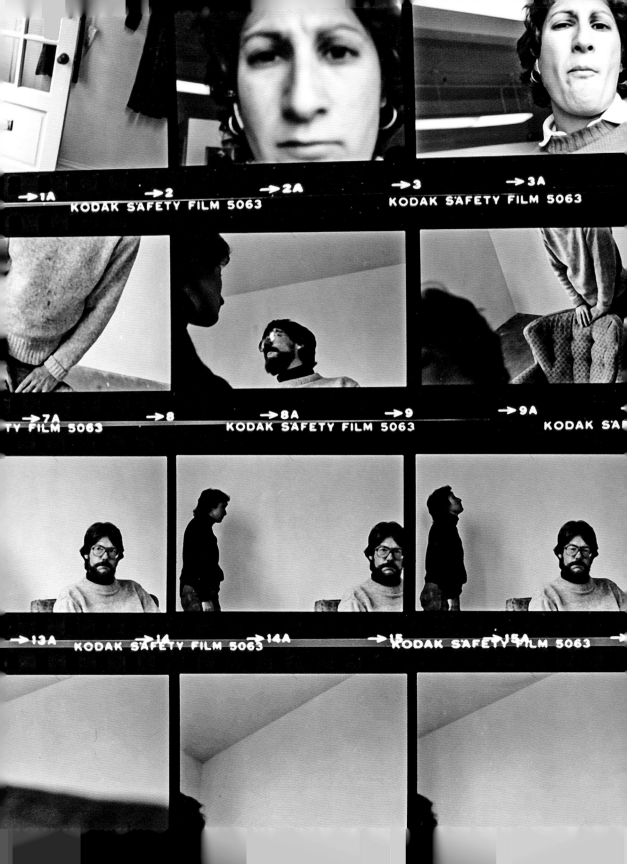

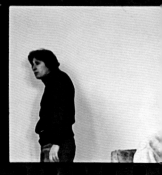

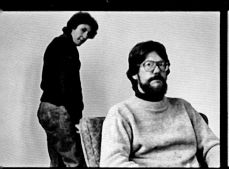
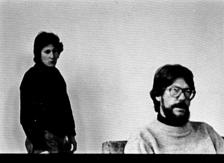
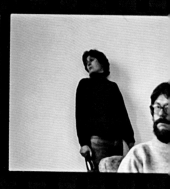

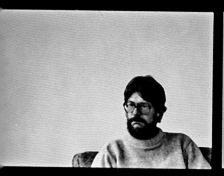
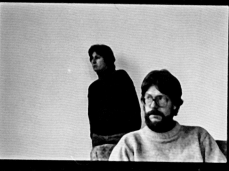
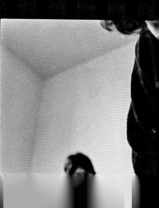

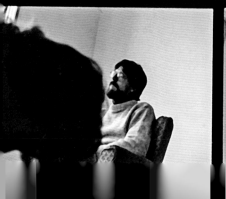
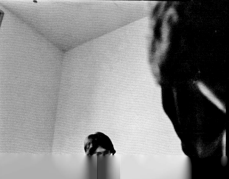

2-21-79

Dear Shirley,

Nancy called at 7:15 this morning to wish
Jeremy a good week. He made faces into
the phone.

Love,

Linda

2-22-79

Dear Shirley,

So the phone rings just as we're about
to eat. It's Nancy inviting him for dinner
next Tuesday. He accepts with pleasure.

Love,

Judy

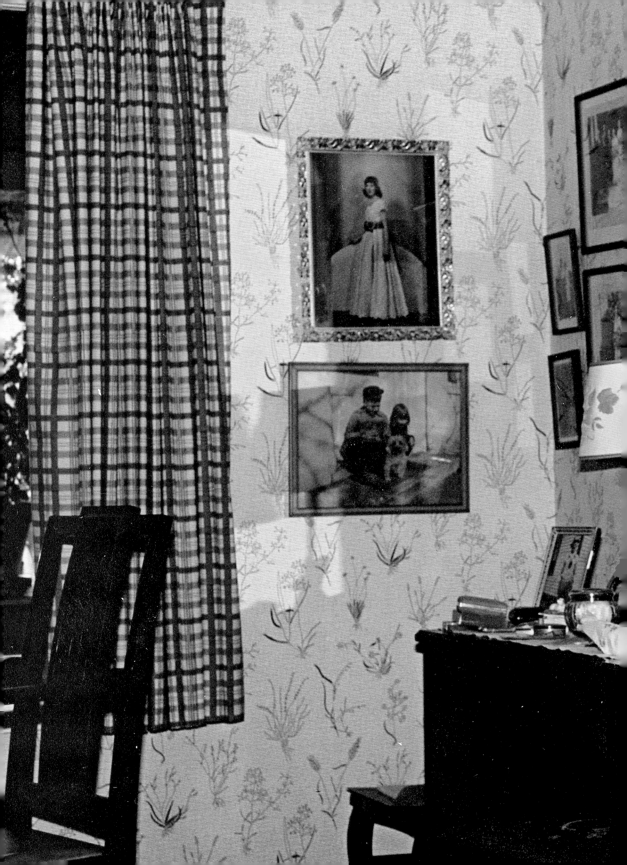

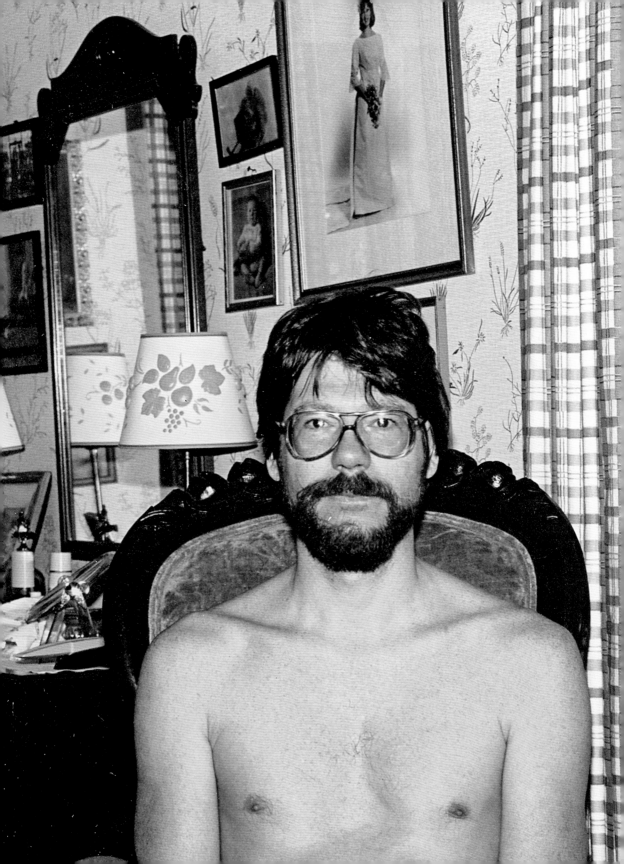

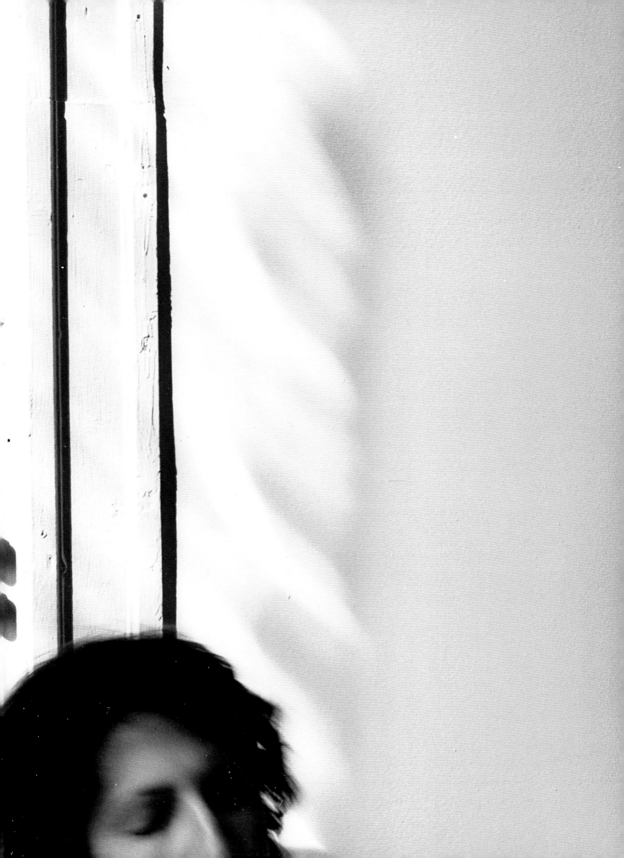

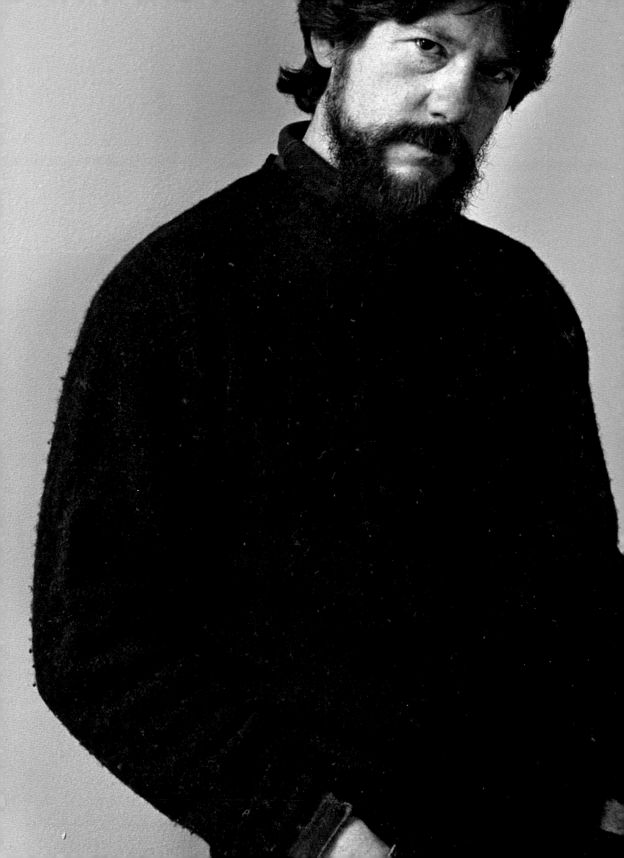

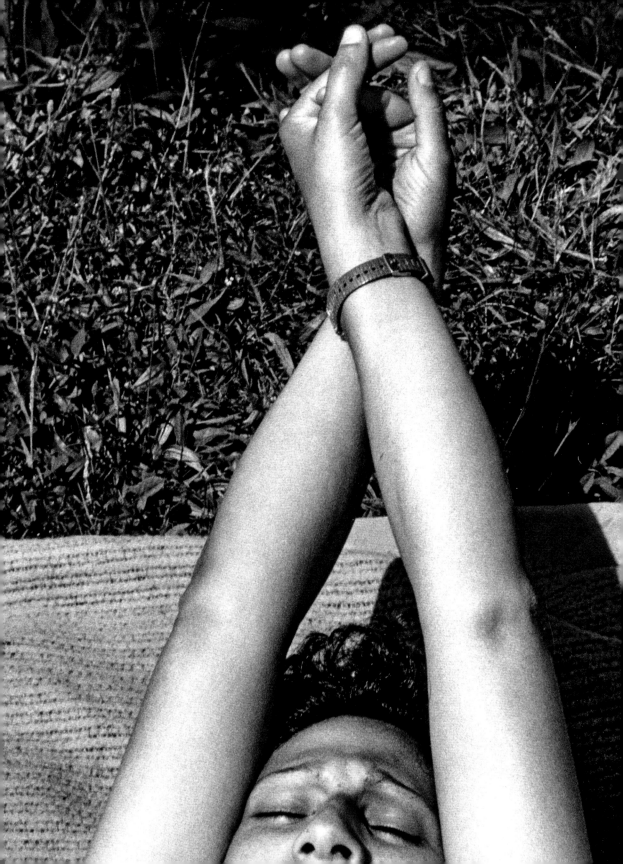

8-11-79

Dear Shirley,

TRY THIS: BY JEREMY BIRCH:

WHY I AM NOT INFATUATED.

Jeremy is not infatuated with Nancy because
an infatuation is when one makes a judge-
mental error and does not know it. If you
make an error and know it, then it is not
infatuation.

I'm considering therapy for myself.

Love,

Linda

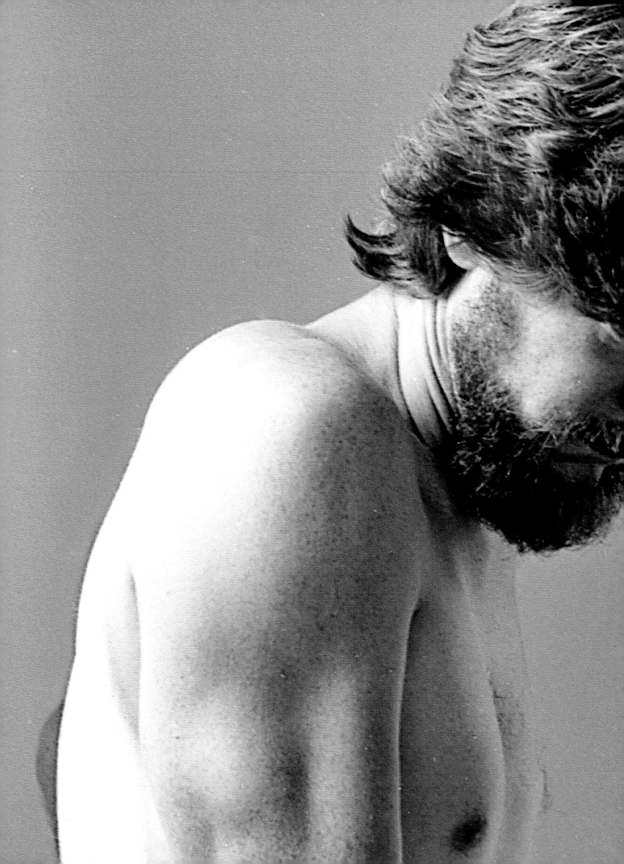

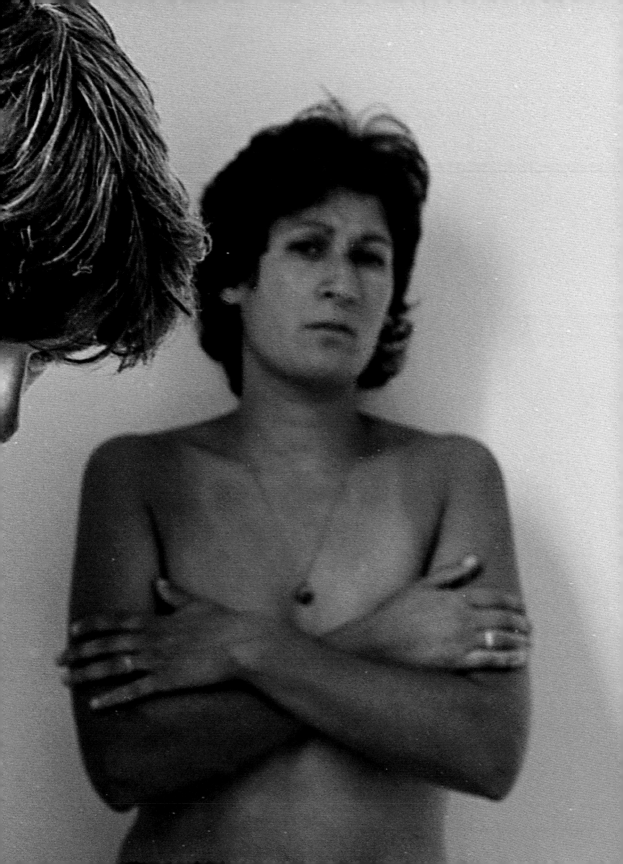

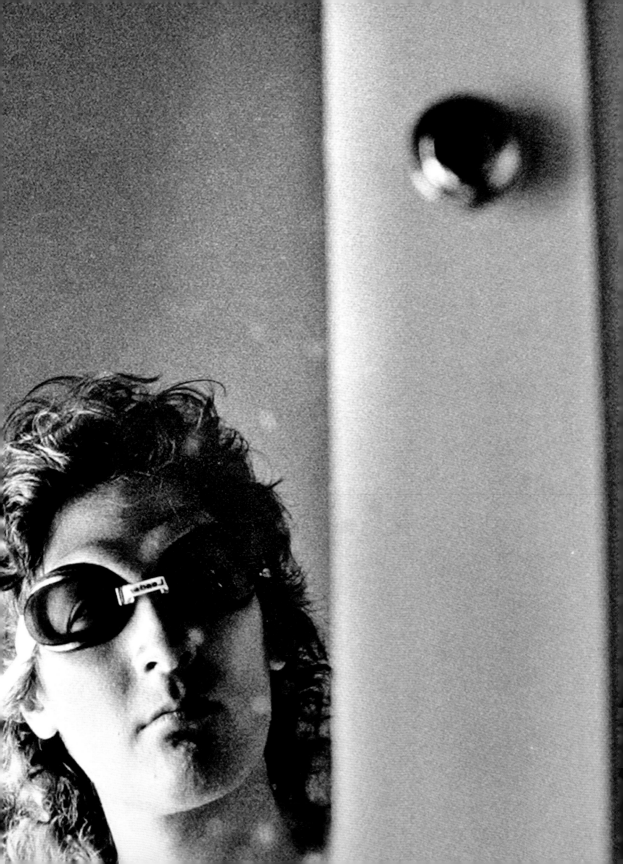

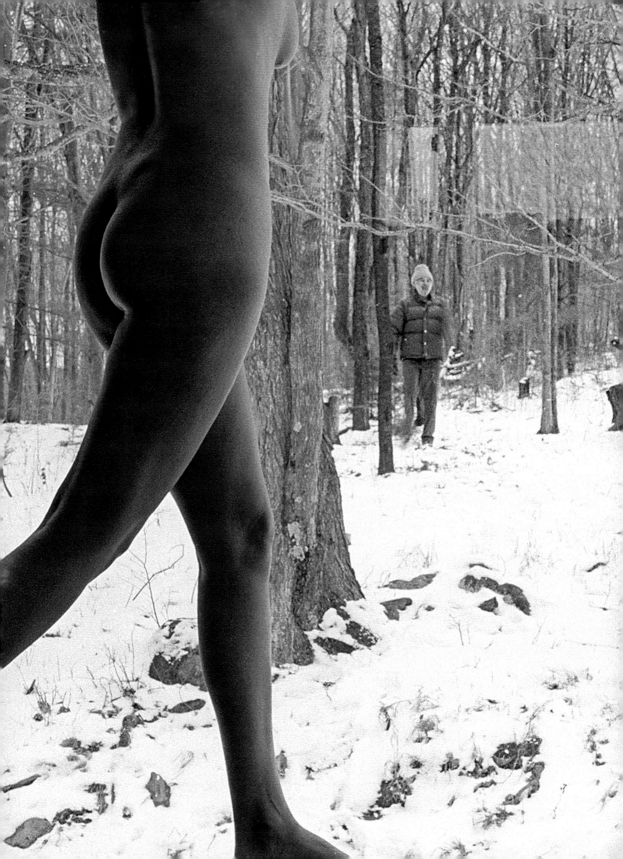

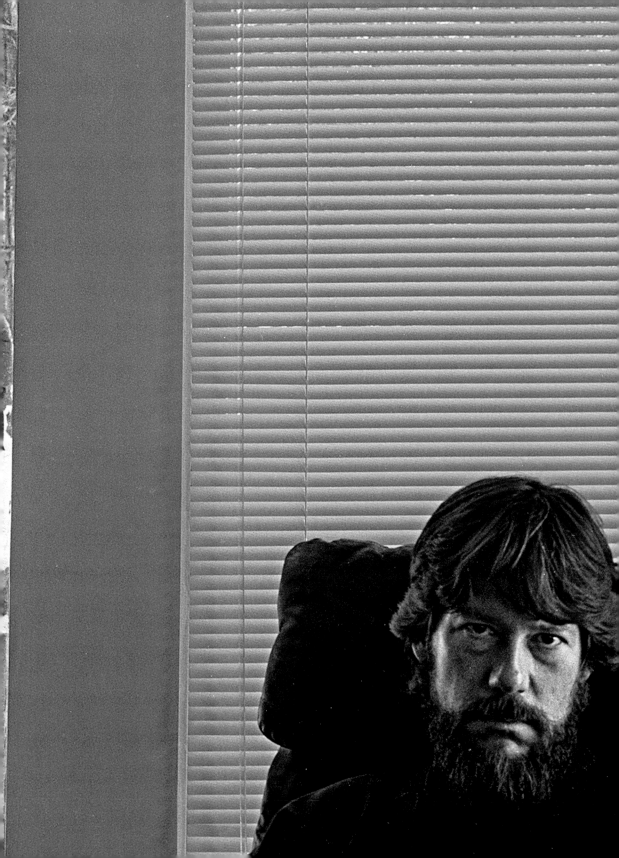

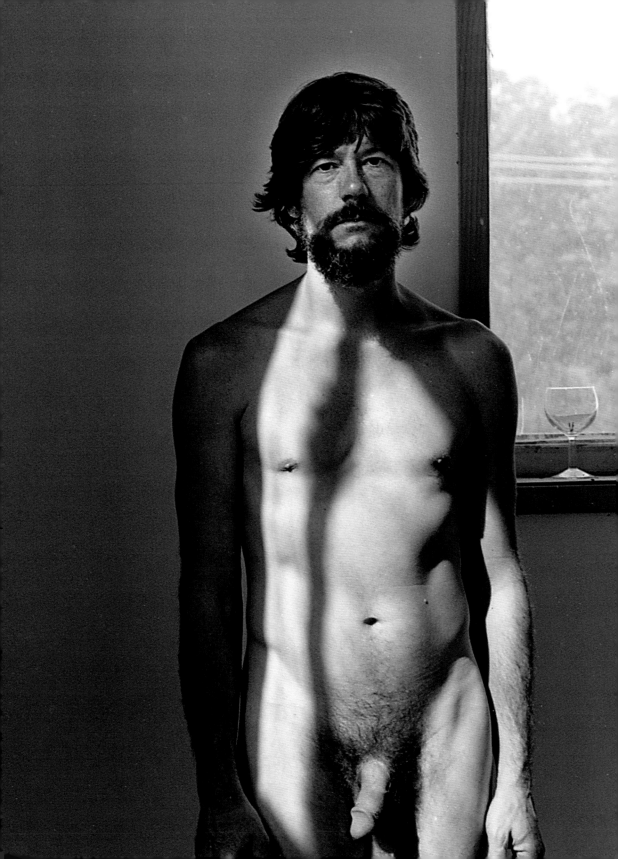

4-30-80

Dear Shirley,

Jeremy feels that in recent months he
become a much more sensitive, emotional
and open person. People are responding
to him in a much warmer way.

Love

Hinda

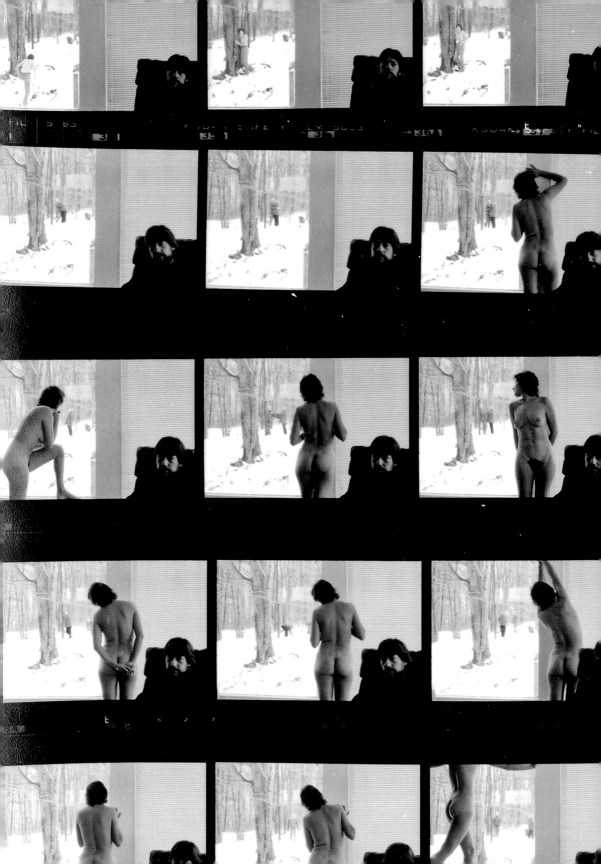

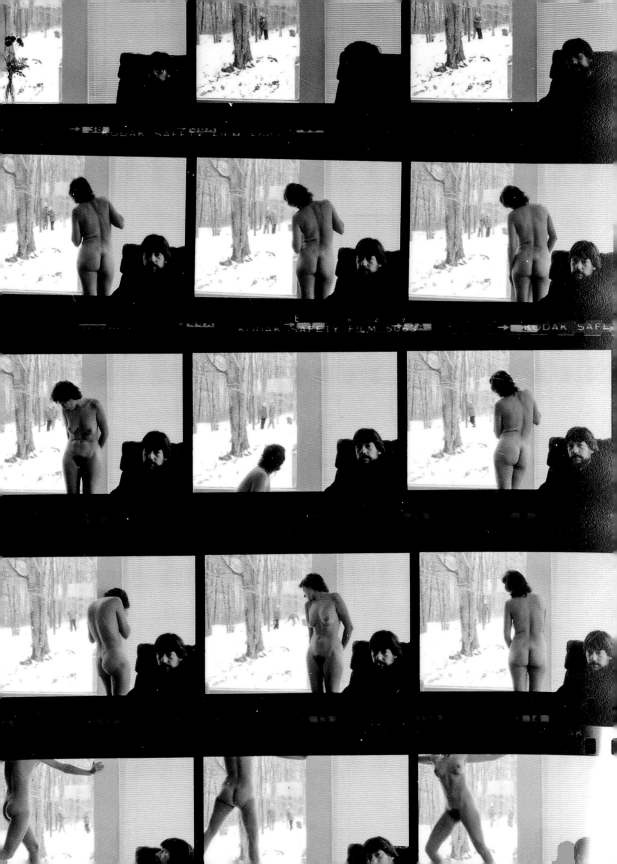

Dear Shirley,

Monday morning at the office: One woman
beaten and kicked out by her boyfriend.
She has no job, 25¢ and lives in Massachu-
setts. One woman with two kids who was
beaten and threatened with a gun, by her
husband, because she'd gone to look for
an apartment with her sister. Her sister
was looking because her boyfriend had raped
her the night before. There was one woman
up in Londonderry in the church basement,
with five kids. The minister had rescued
her. Her husband had been chasing her
with the family Ford. The kids have no
shoes, no pampers, no food. I have no
idea why he was chasing her. Peggy and
I did restraining orders all morning at
the shelter.

I went back to the office for lunch and
made the mistake of answering the phone.
A woman was near hysteria because her
husband beats her up whenever he gets
drunk which is every other weekend. She's
all alone at the end of a dead end road
living in a trailer and doesn't know
any other people in the area. She has
two small children and she wants to get
out and go to her mother in Florida. I
asked the police to go get her.

Love,

Linda

7-3-80

Dear Shirley,

It's my house too, and I earned
it and I helped build it. Why do
I keep feeling like I'm the
one who has to leave it?

It's time I quit acting like it's
my fault.

Love,

Hinda

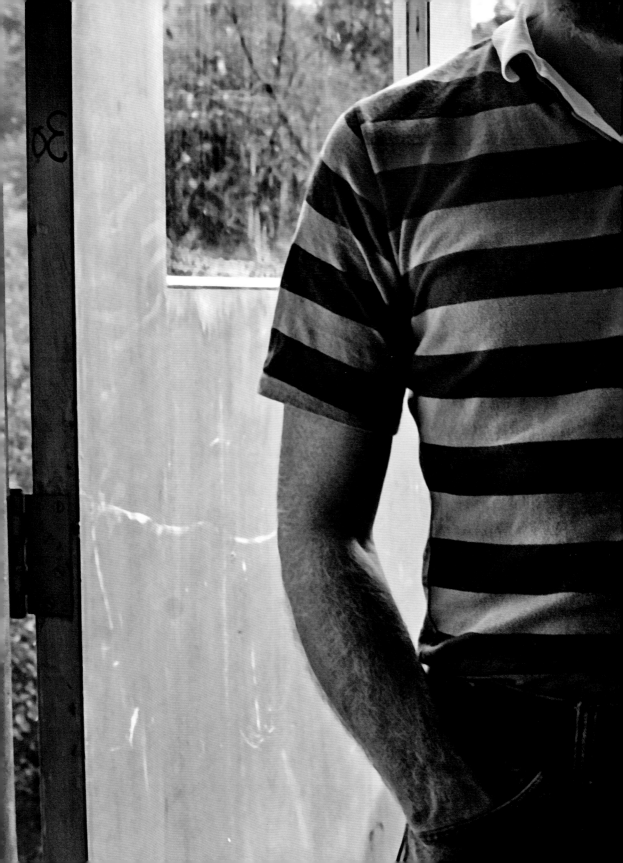

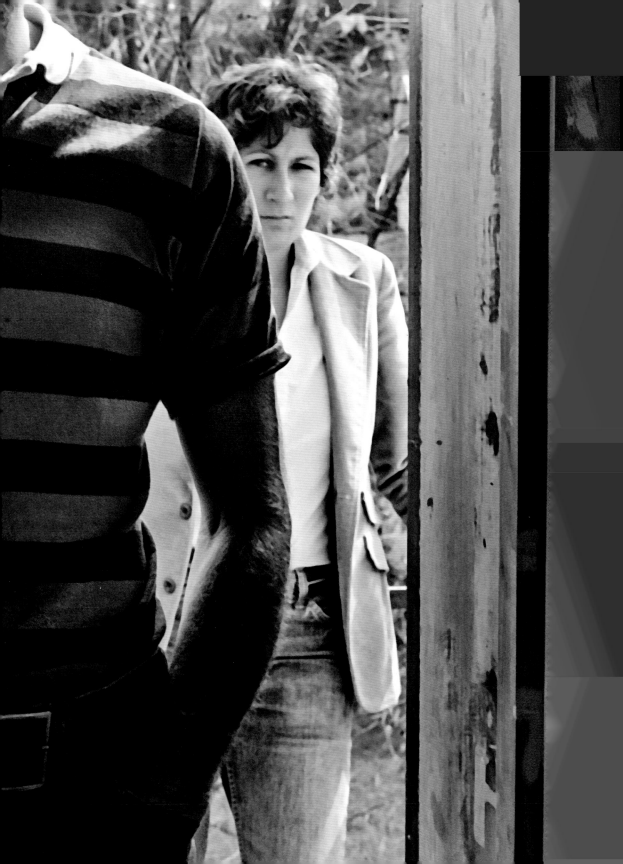

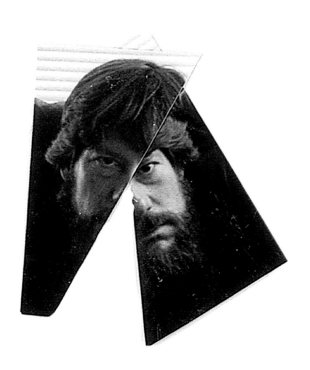

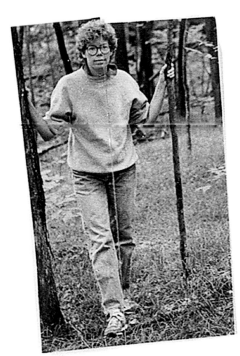

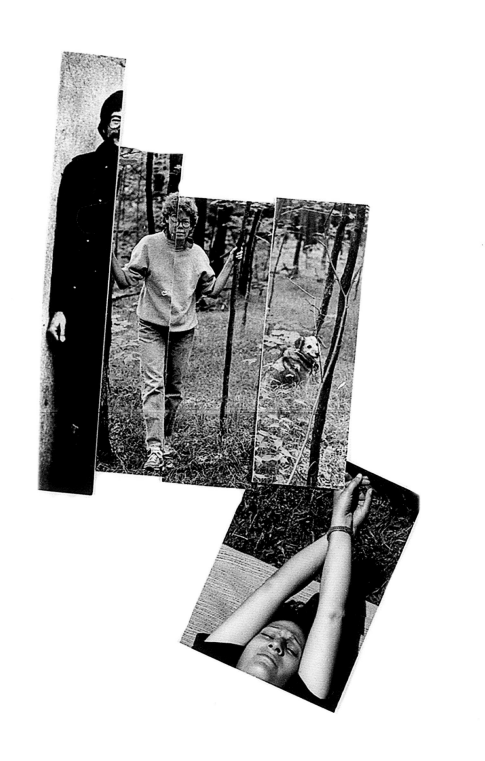

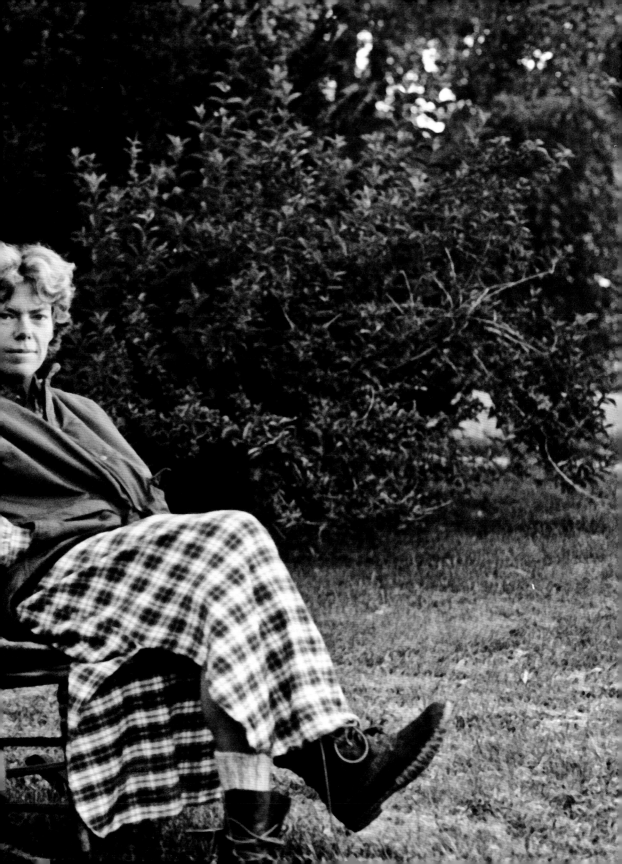

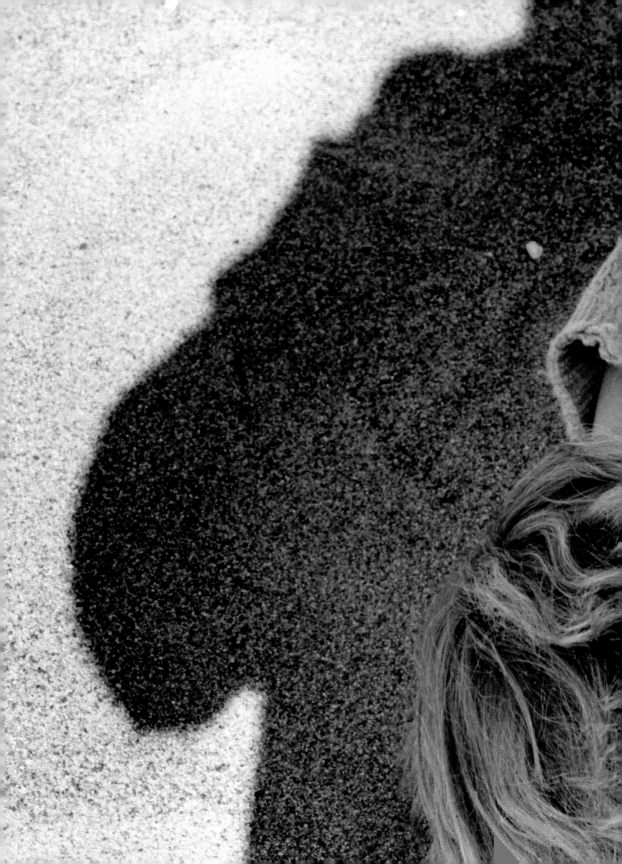

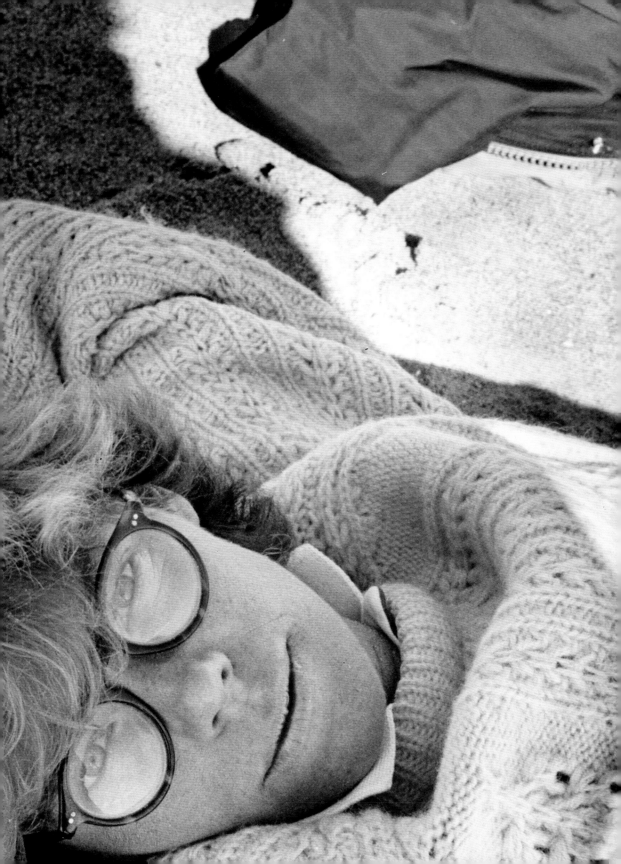

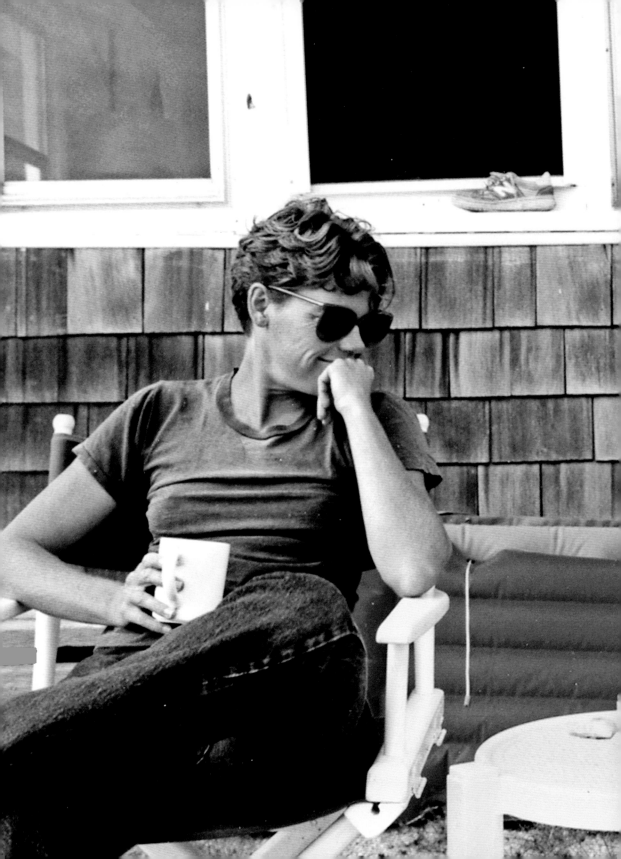

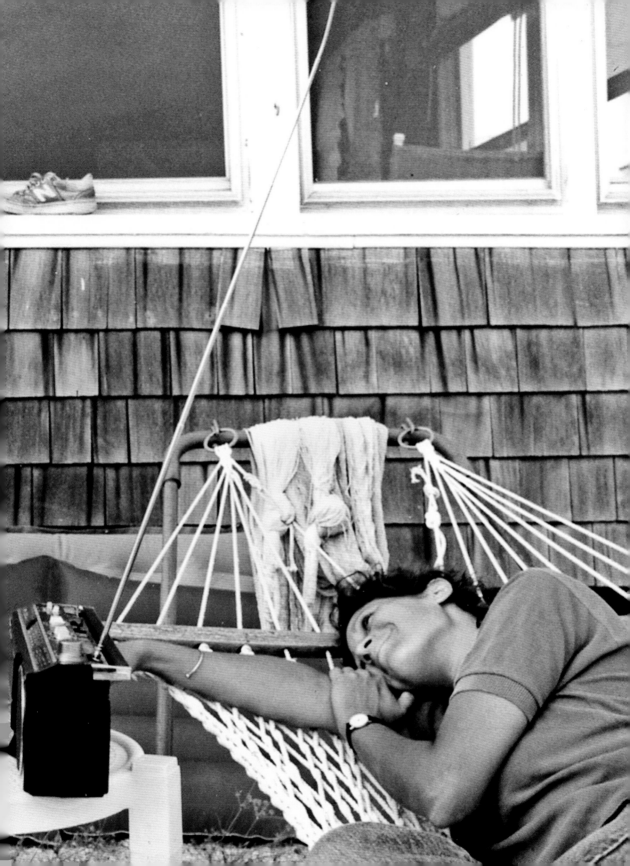

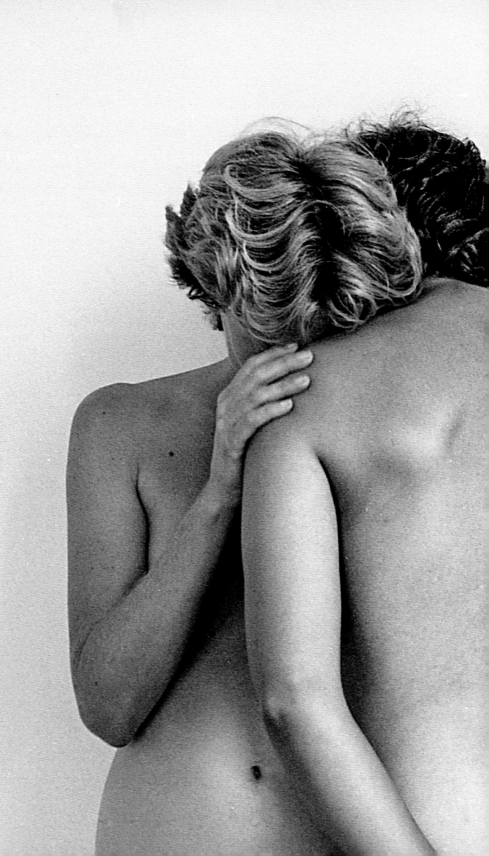

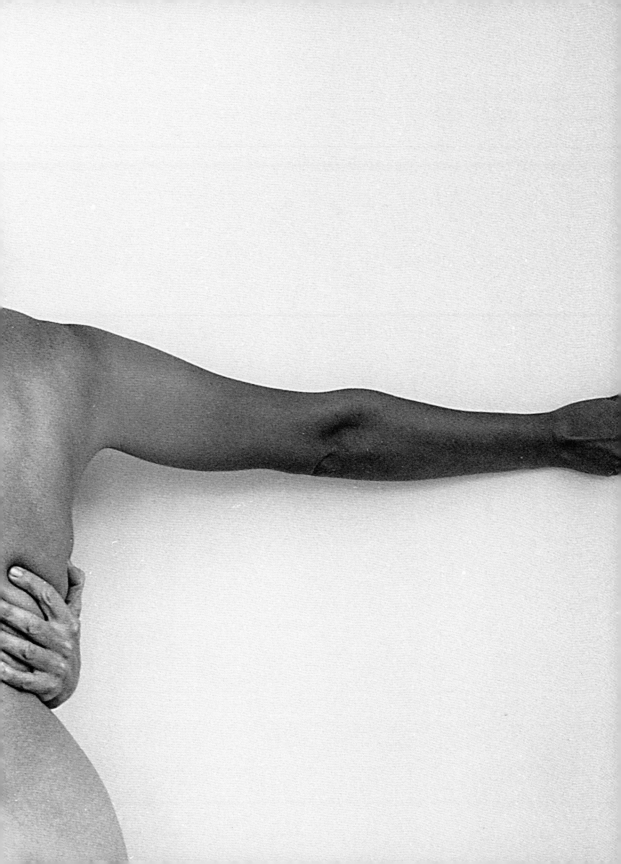

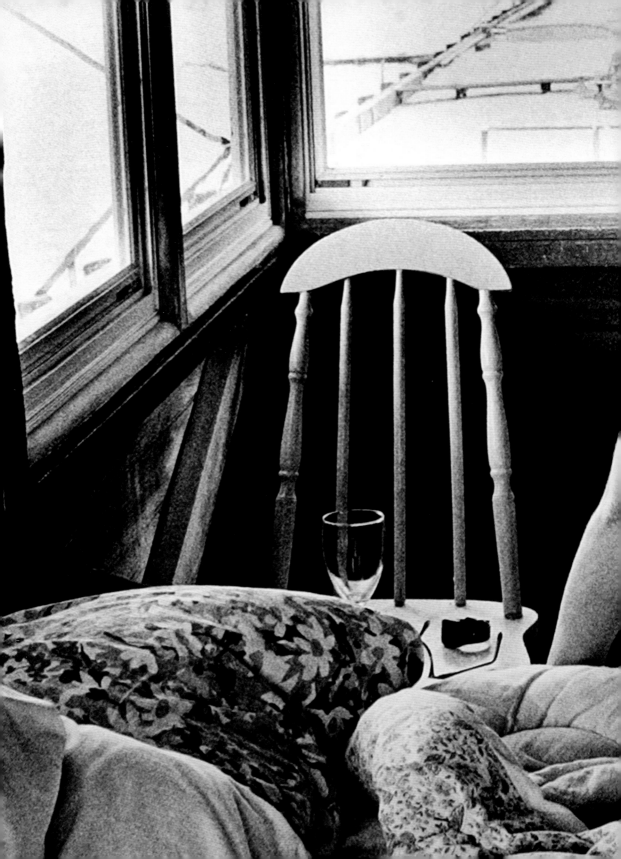

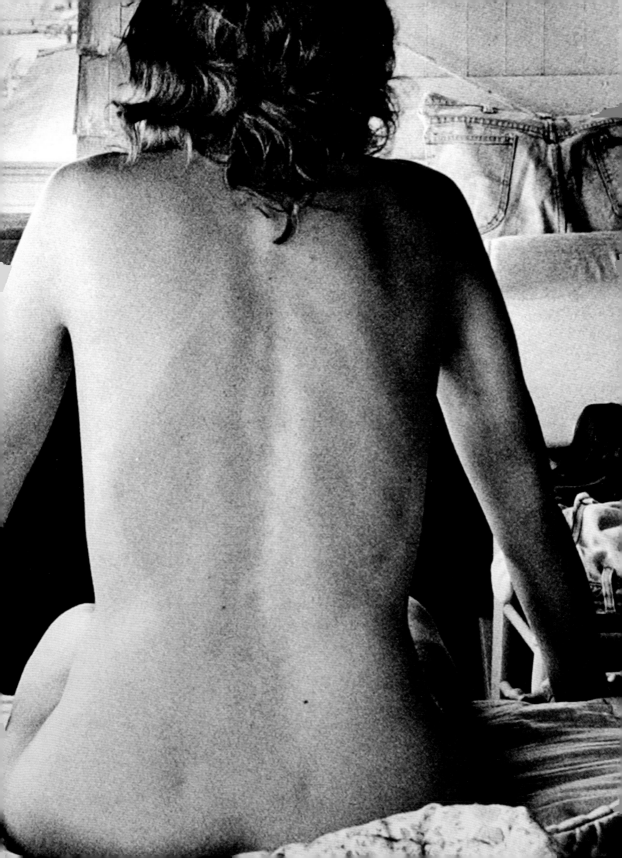

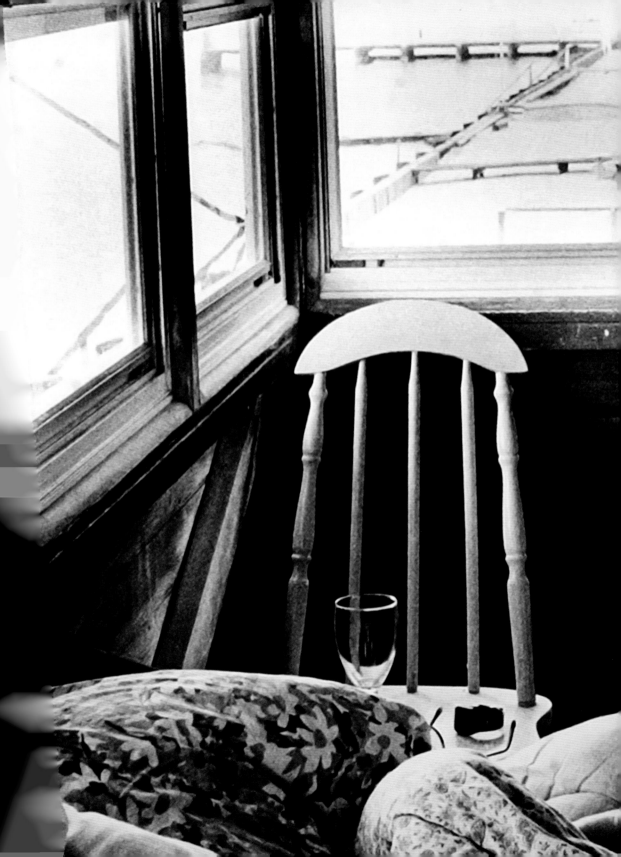

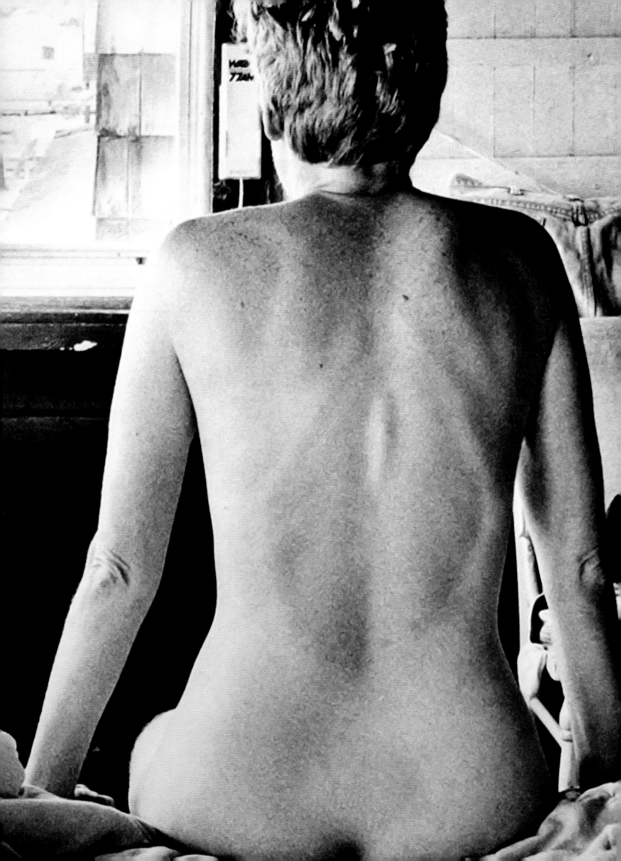

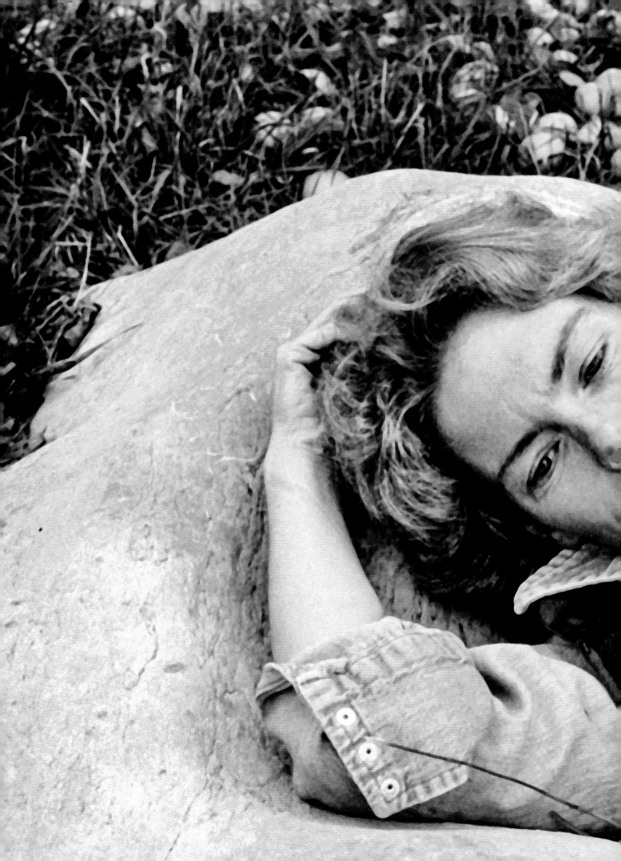

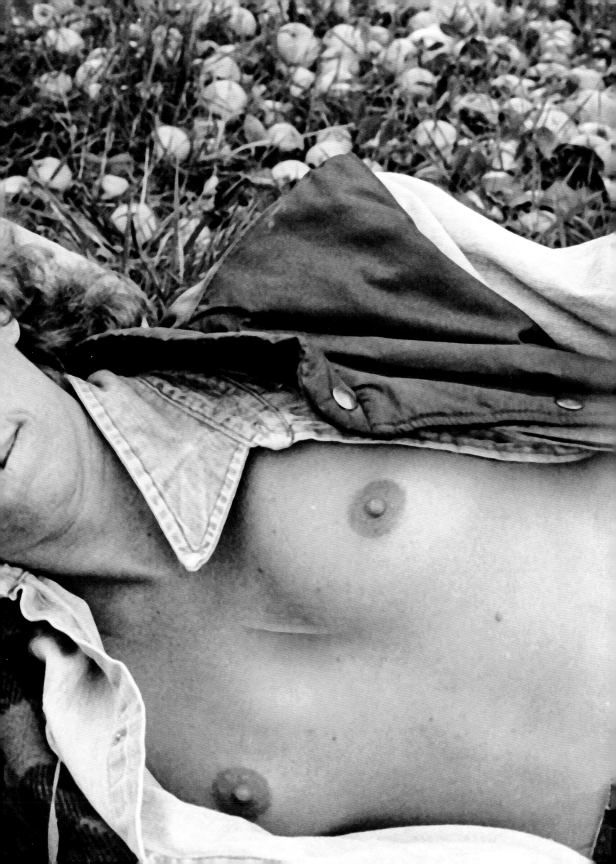

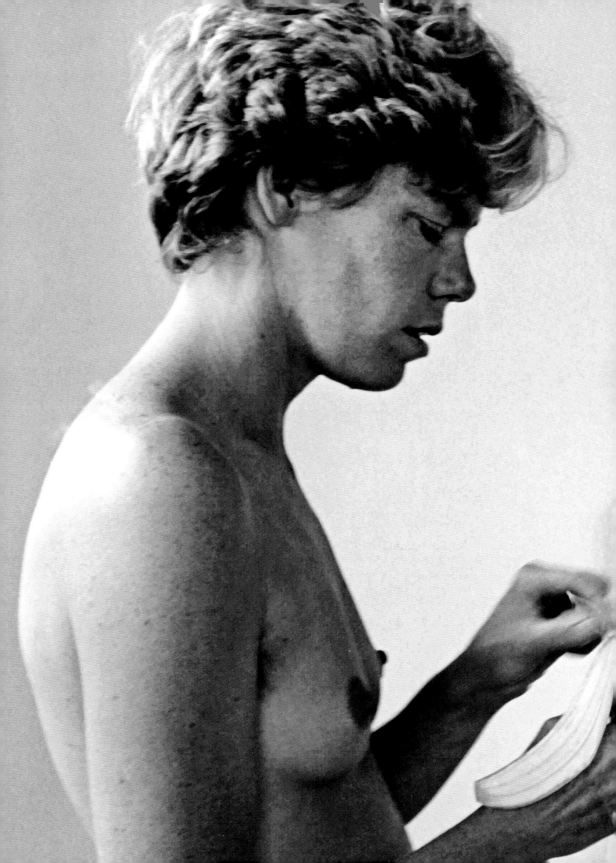

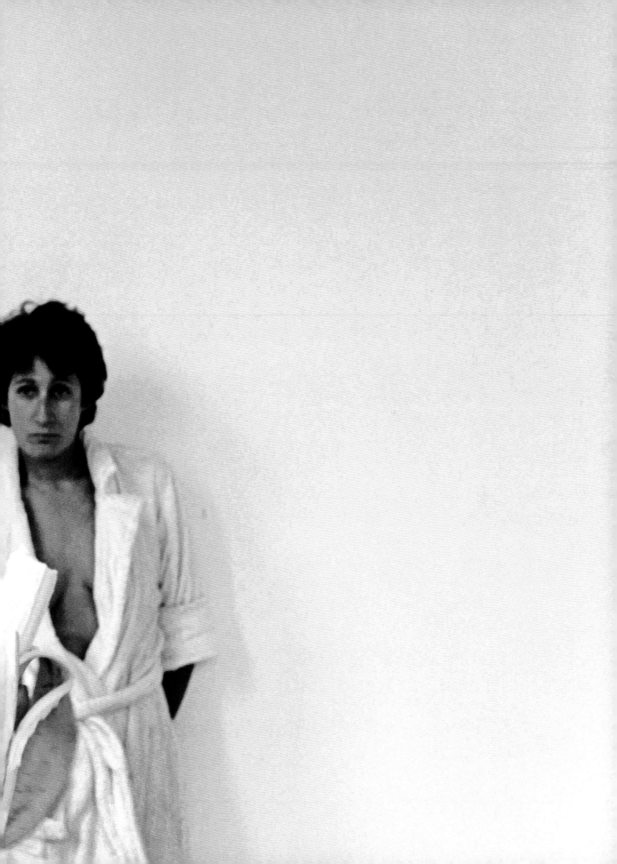

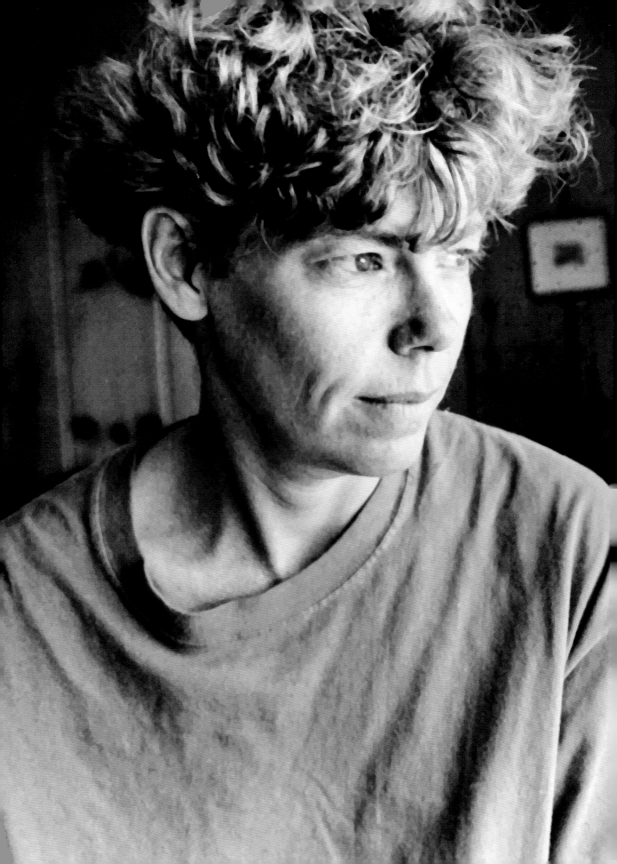

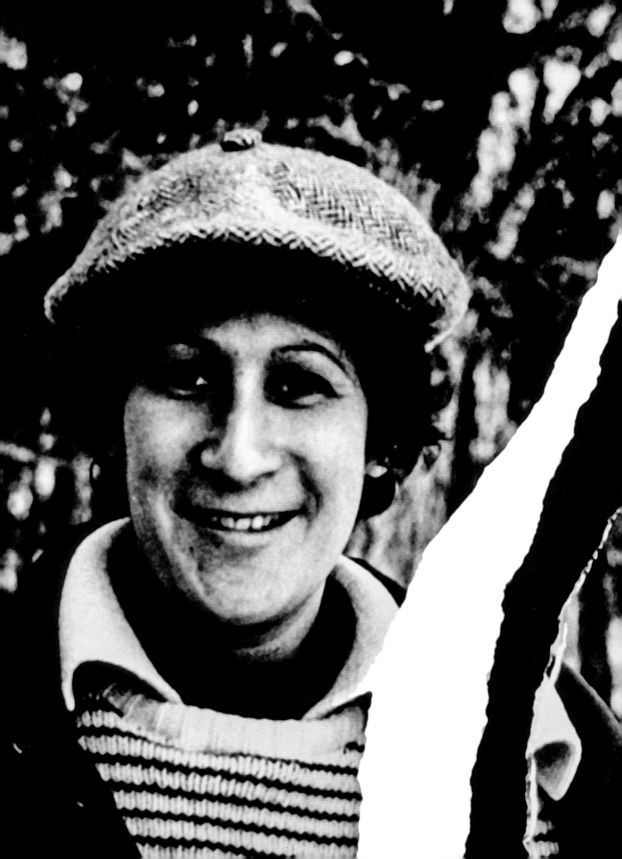

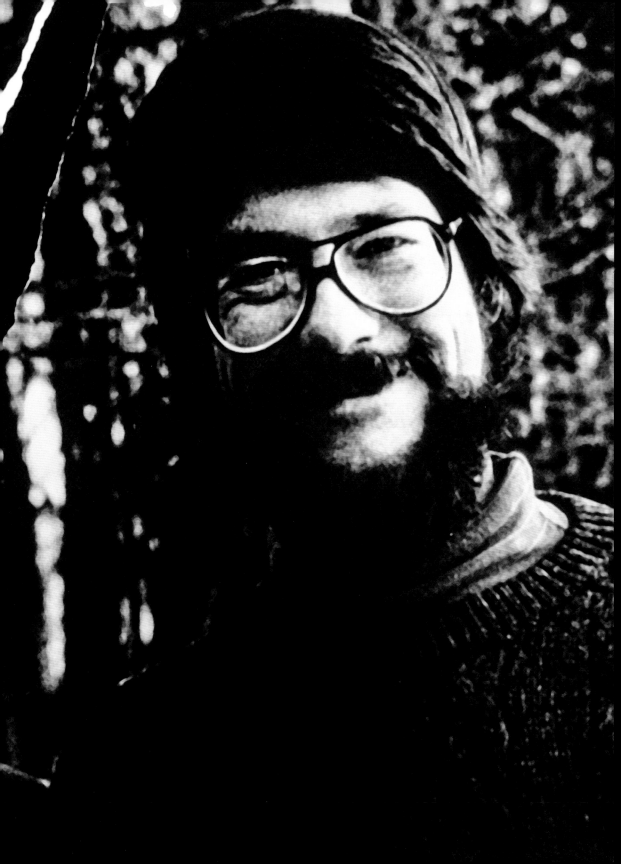

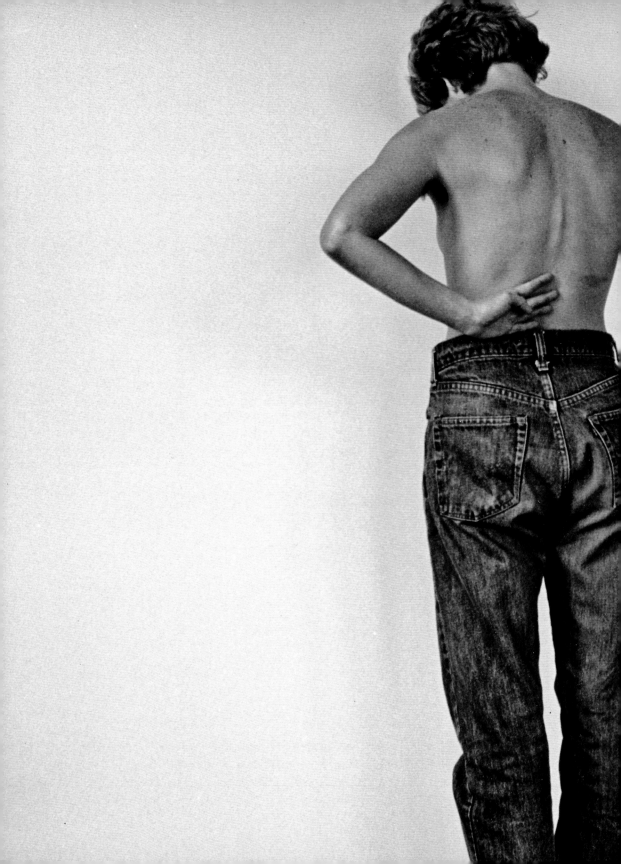

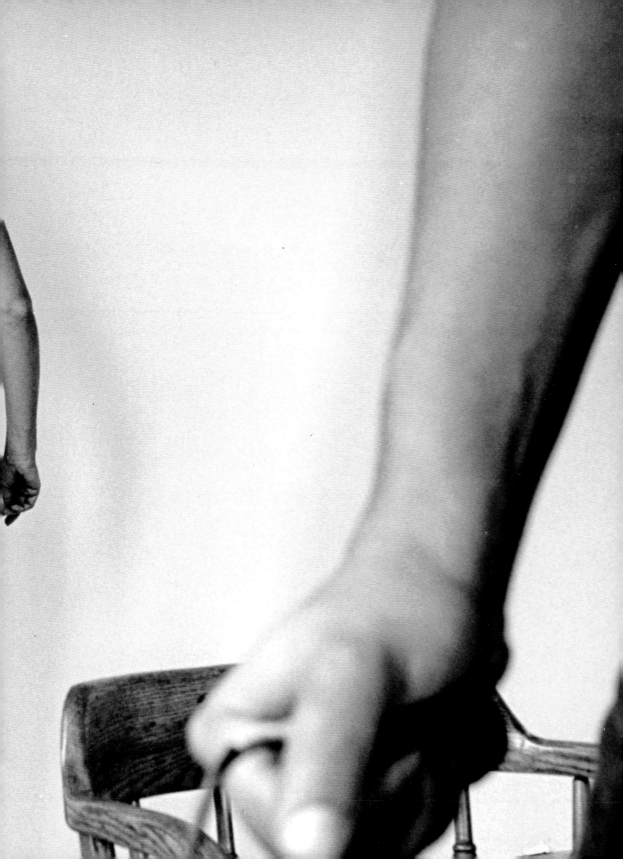

10-5-81

Dear Shirley,

I guess uncertainty is the key word. Susan
and I love one another. But neither of us
is sure what we are willing to give up to make
a committment to one another.

Am I willing to say my marriage with Jeremy
will never work?

Love,

Hinda

10-21-81

Dear Shirley,

After several weeks of feeling panicked
and sad with one another, Susan and I
are coming out of the hard place and
into a positive sense of our selves.
Time together is easier and happier.
We both wish that we had easier
schedules in terms of getting to-
gether more often.

Love,

Linda

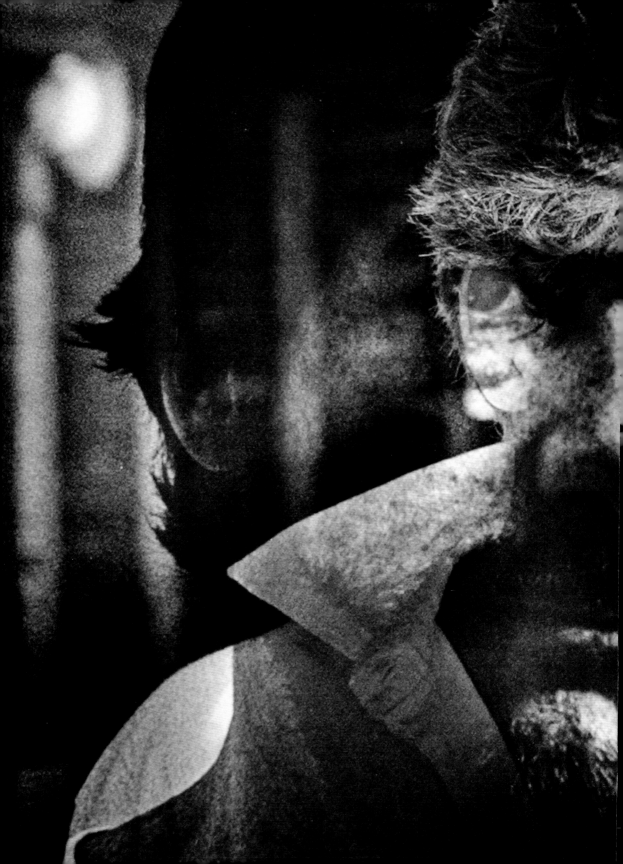

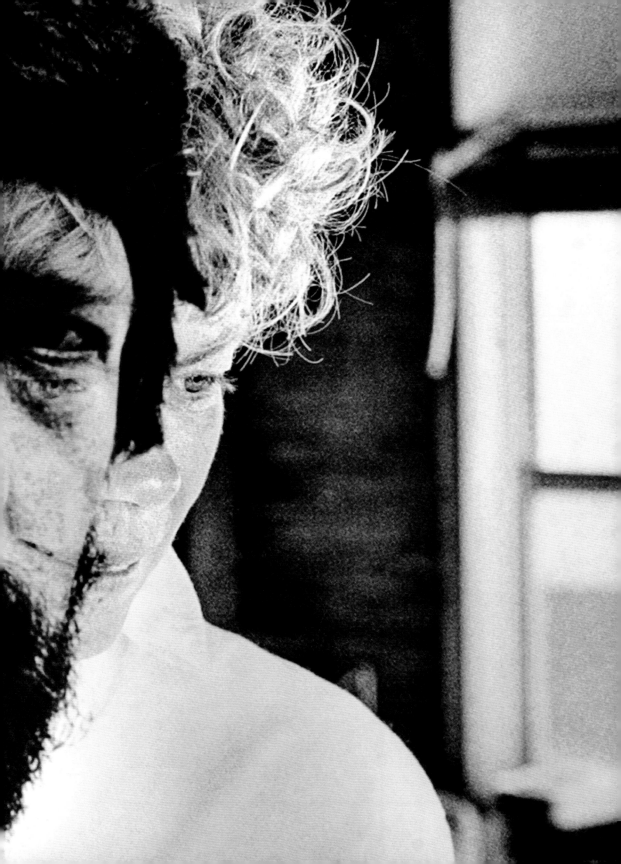

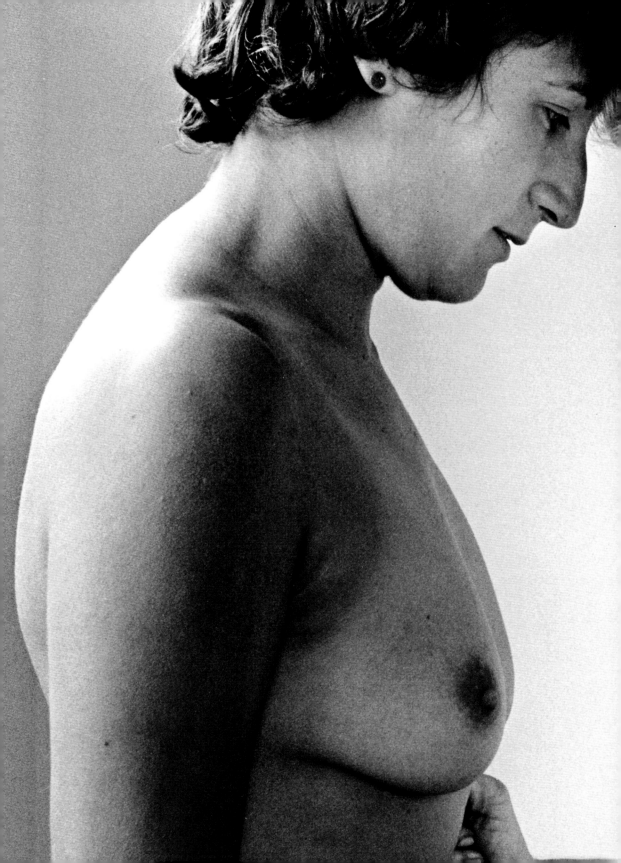

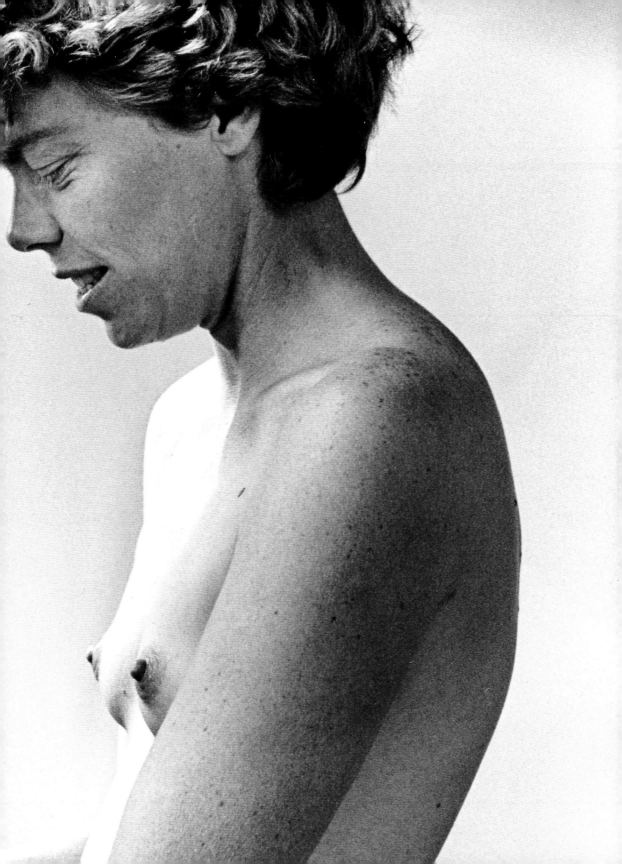

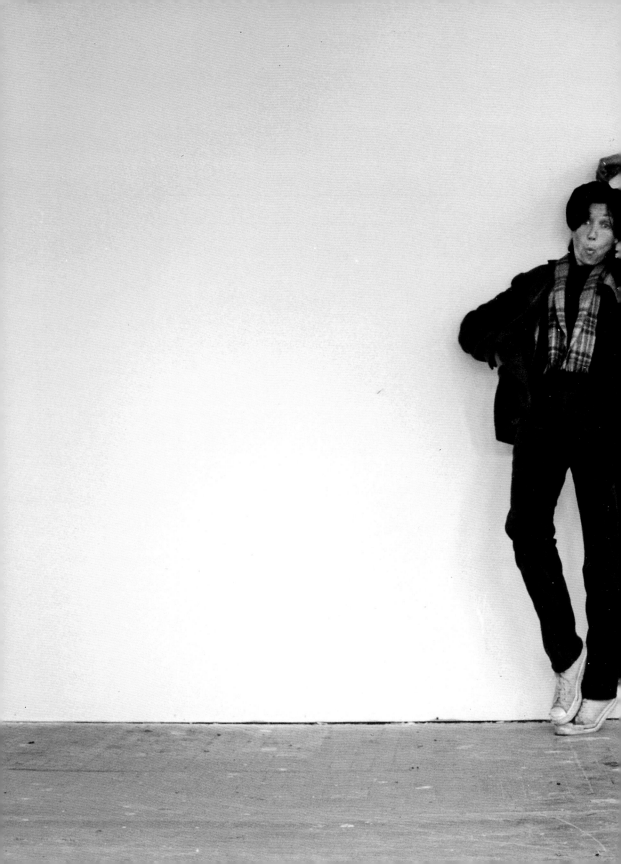

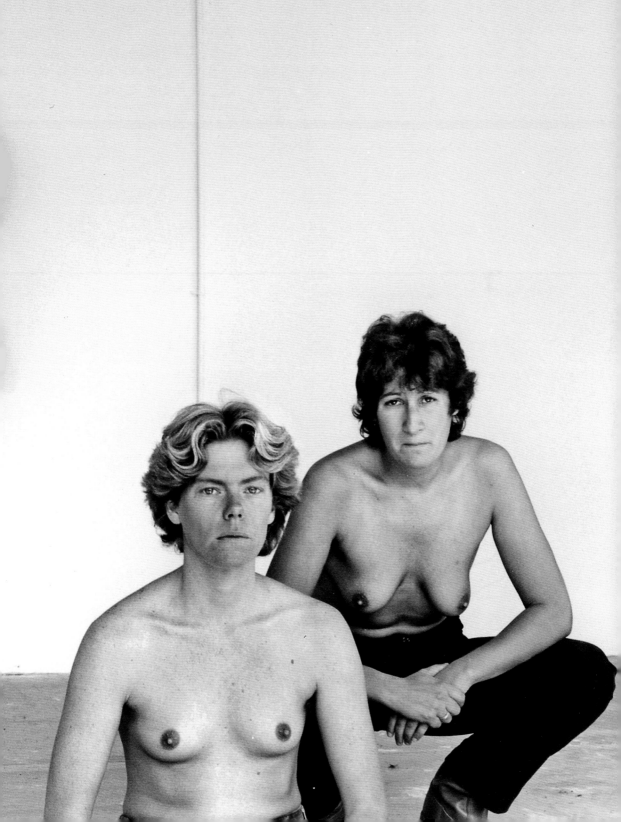

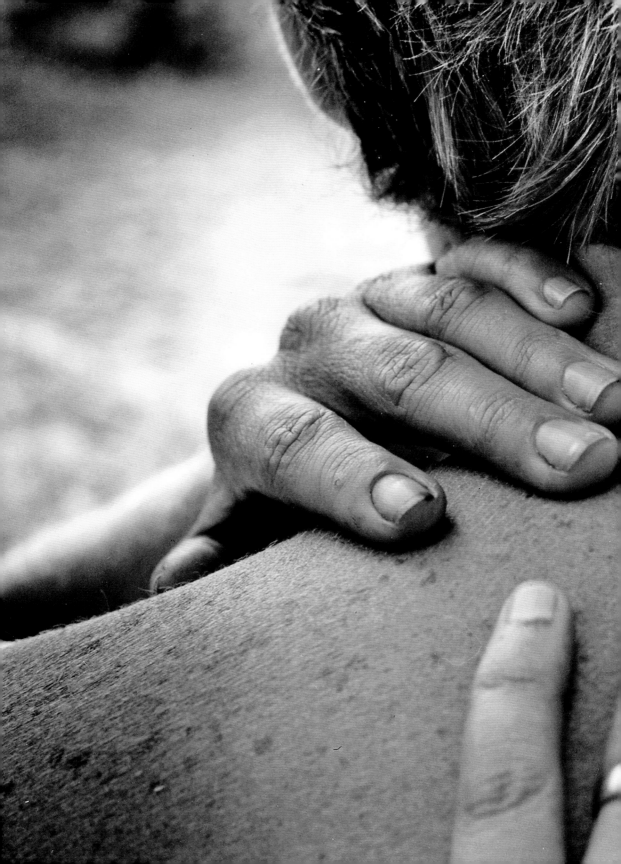

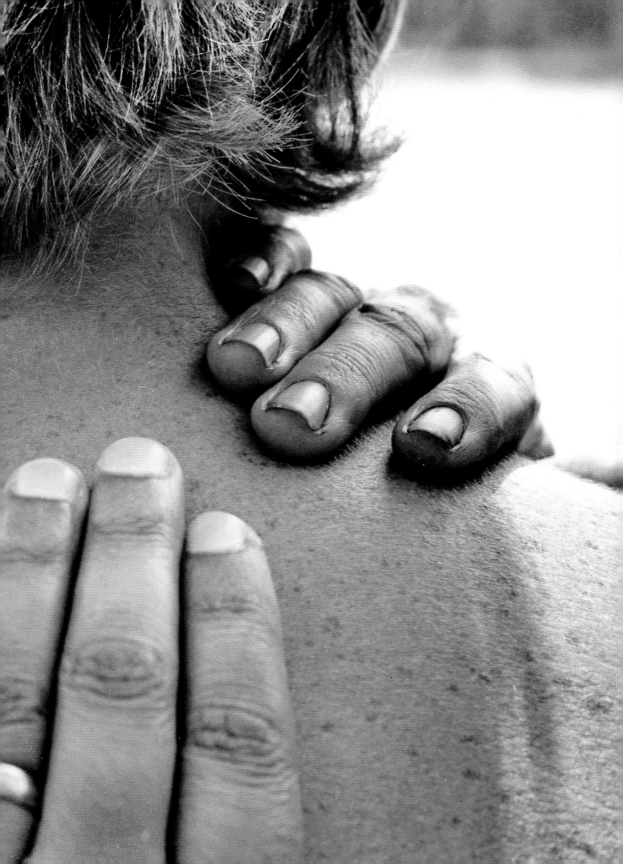

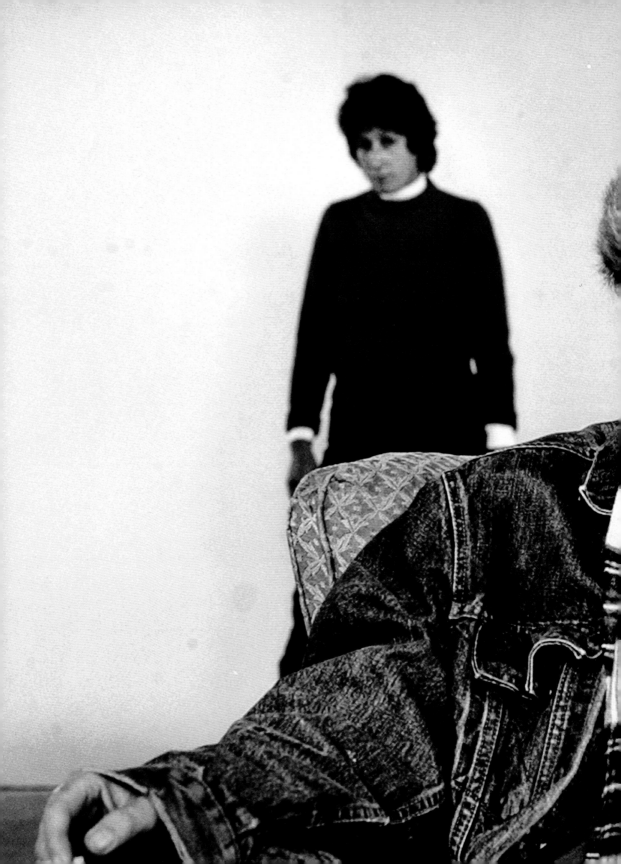

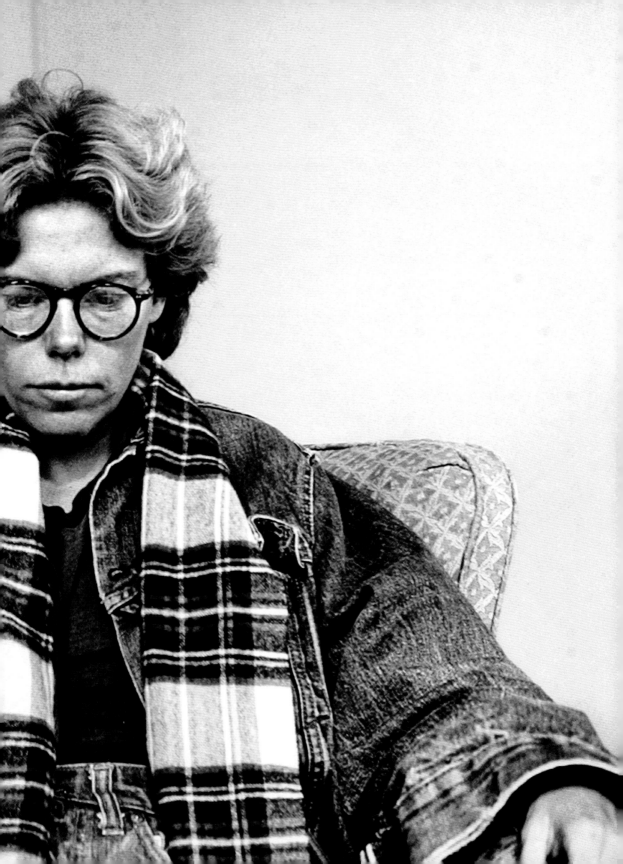

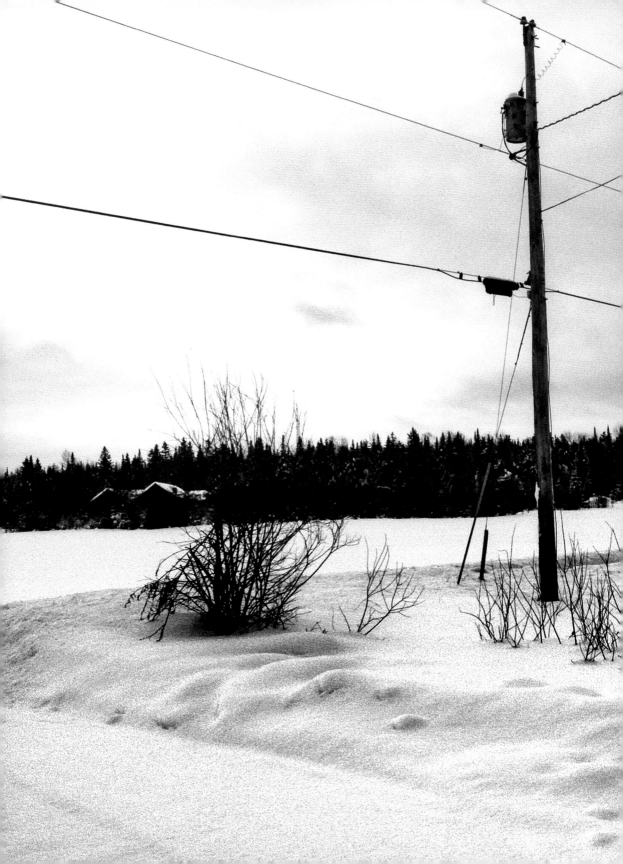

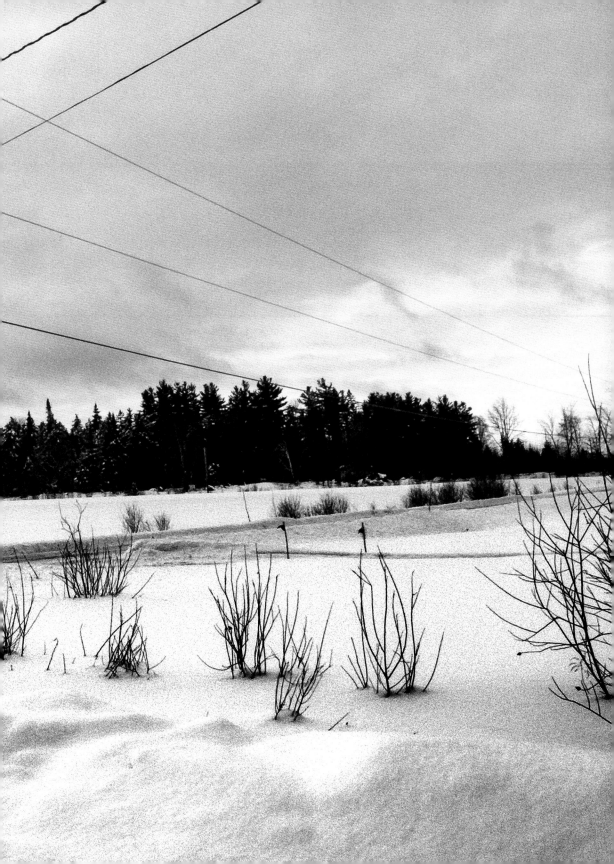

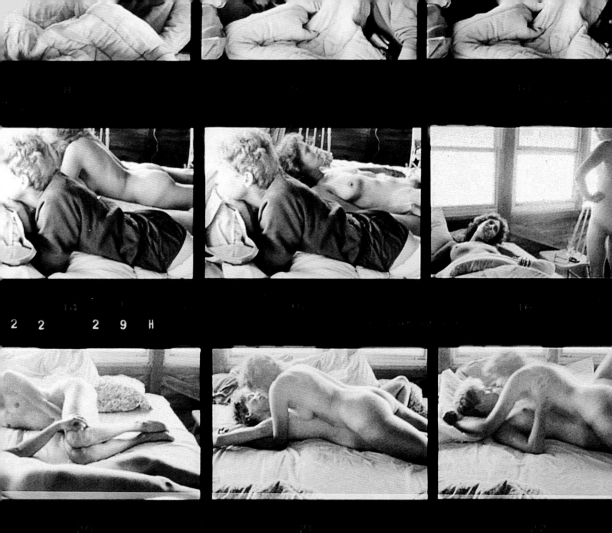

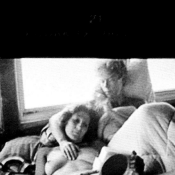

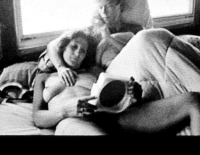

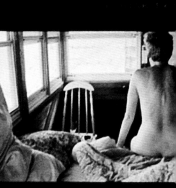

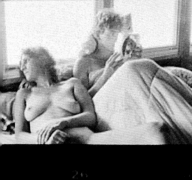

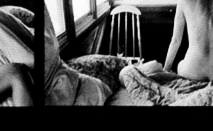

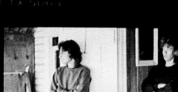

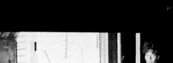

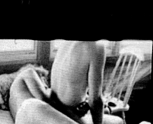
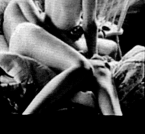
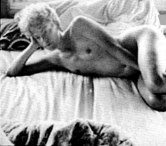

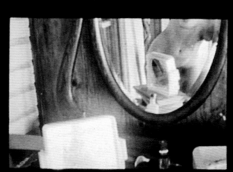

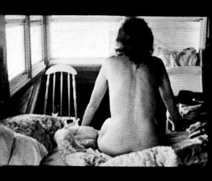
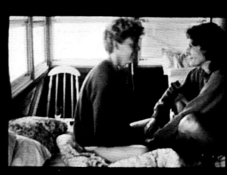
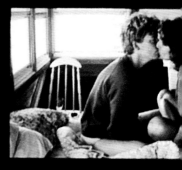
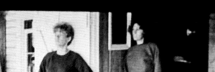
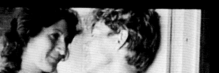

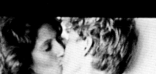

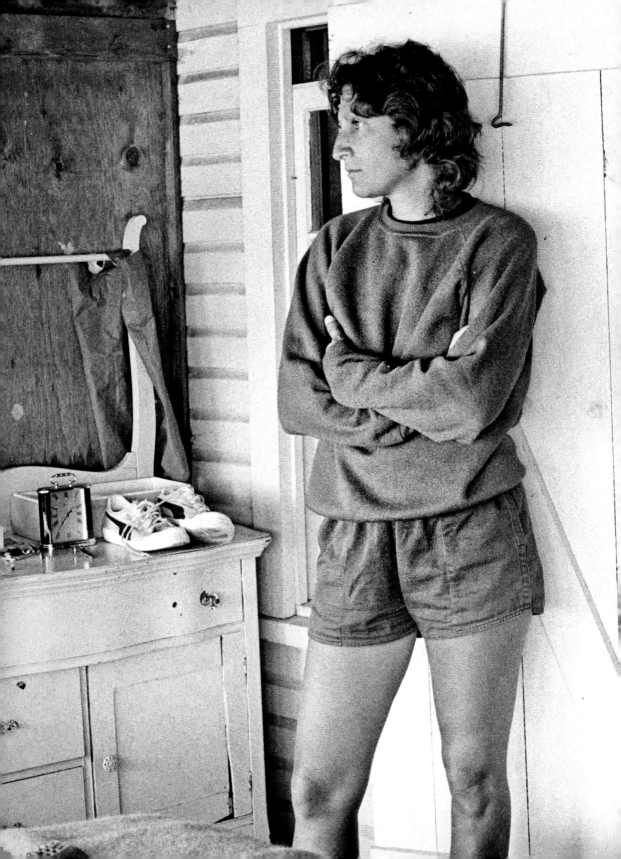

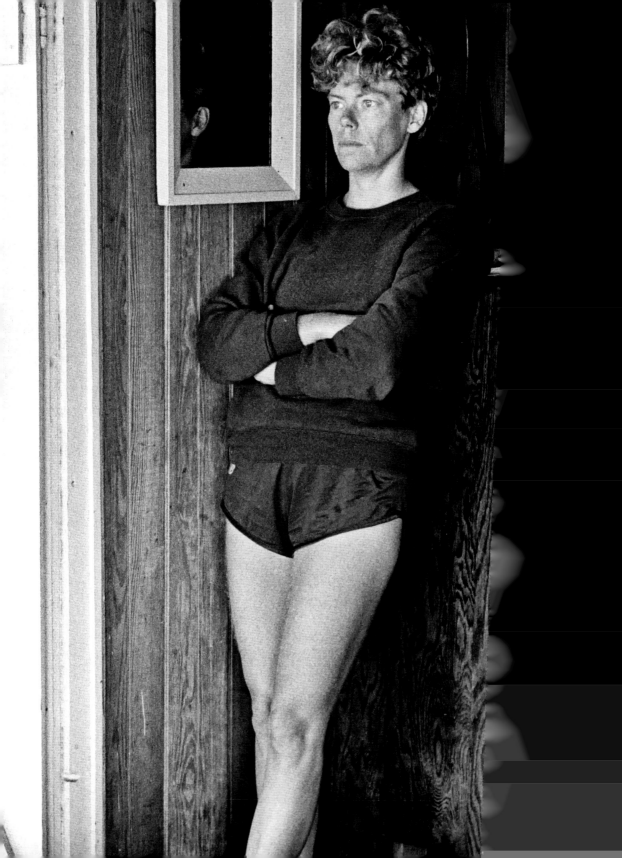

1-24-82

Dear Shirley,

I am feeling desperate about a job—or
lack thereof. Those I've applied for have
not worked out. Those I've tried to solicit
have put me on ice. It's a desperate feeling.
It can also be humiliating.

Love,

Hinda

2-2-82

Dear Shirley,

Susan is a major part of my life. She is a
major part of my time and my energy and my
emotions.

We've both alienated people. People who know
me as straight, or a teacher or Jeremy's wife
have a hard time looking at me.

People who know Susan as a radical and knew
her previous lover, have trouble with a new
face.

Yet our love for one another grows. We've
both opened up in new ways. It feels risky
and challenging and I feel like I posses new
strengths.

Twenty years from now, Susan and I may not
even like one another. Or maybe we'll have
nothing to say, or everything to argue.
But for now this is my life and I love it.

Love,

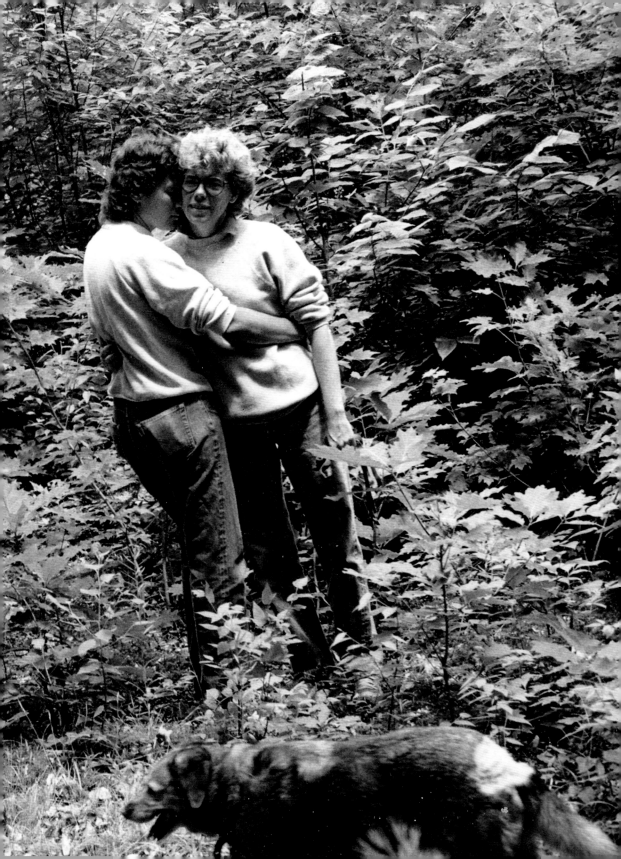

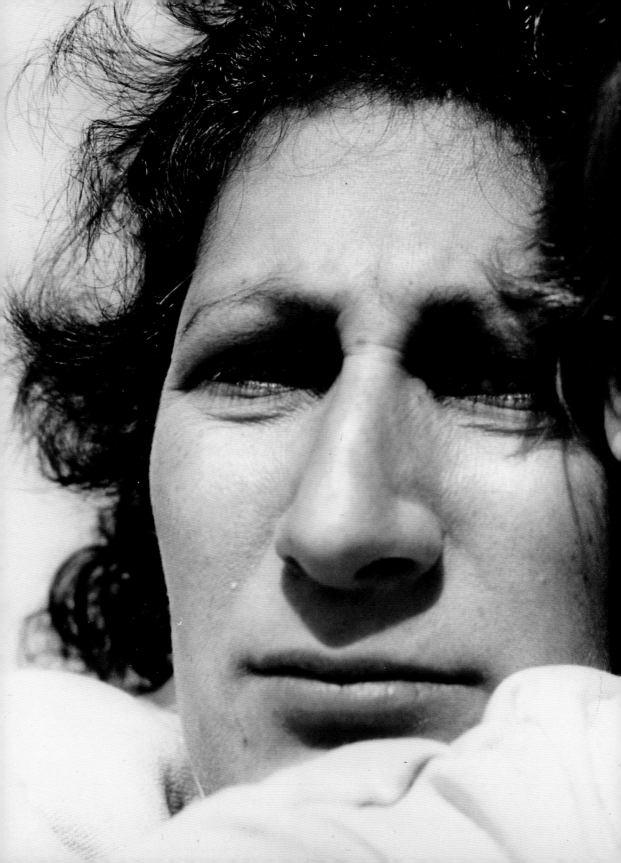

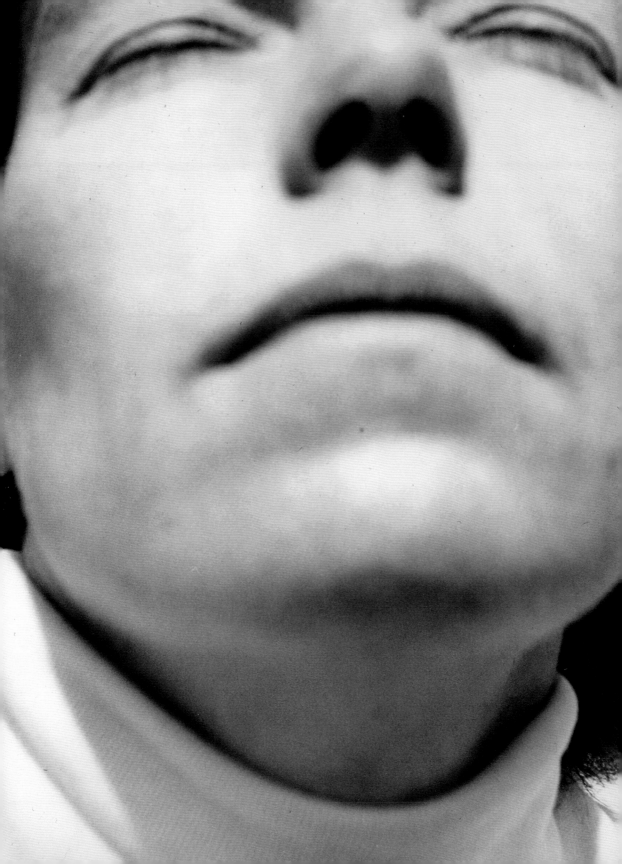

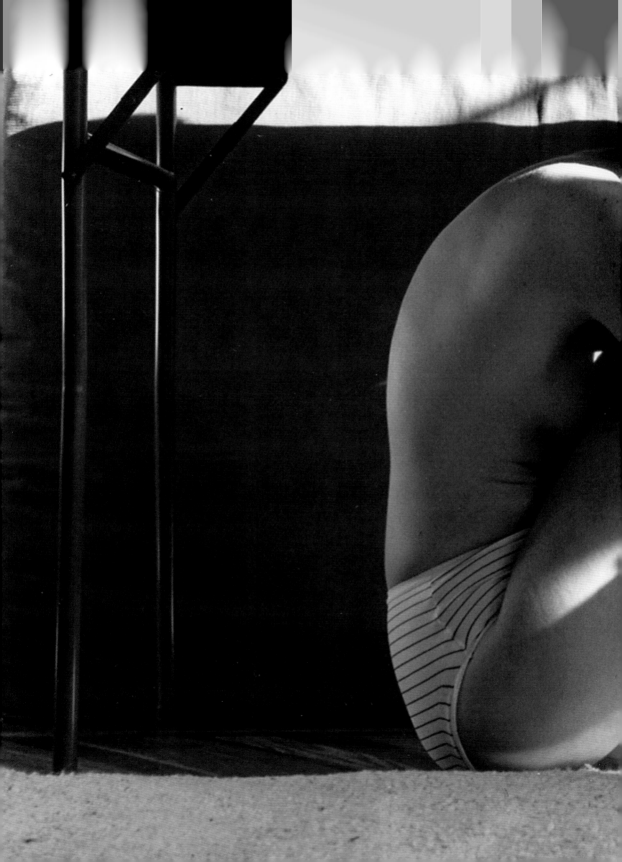

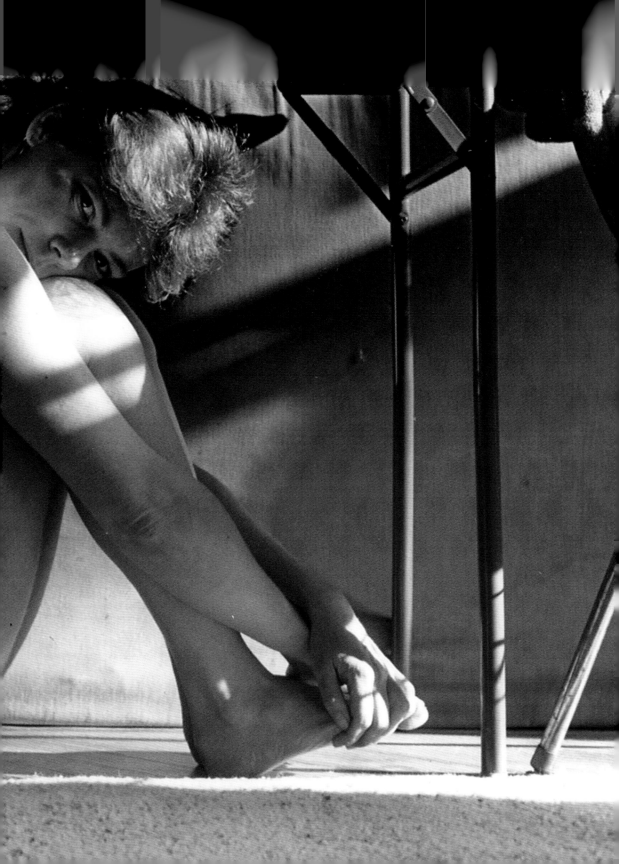

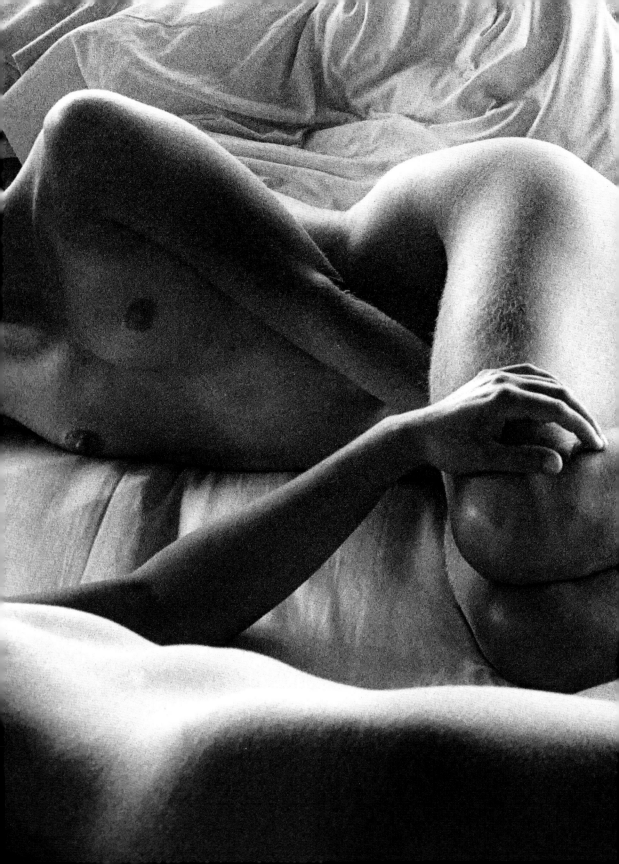

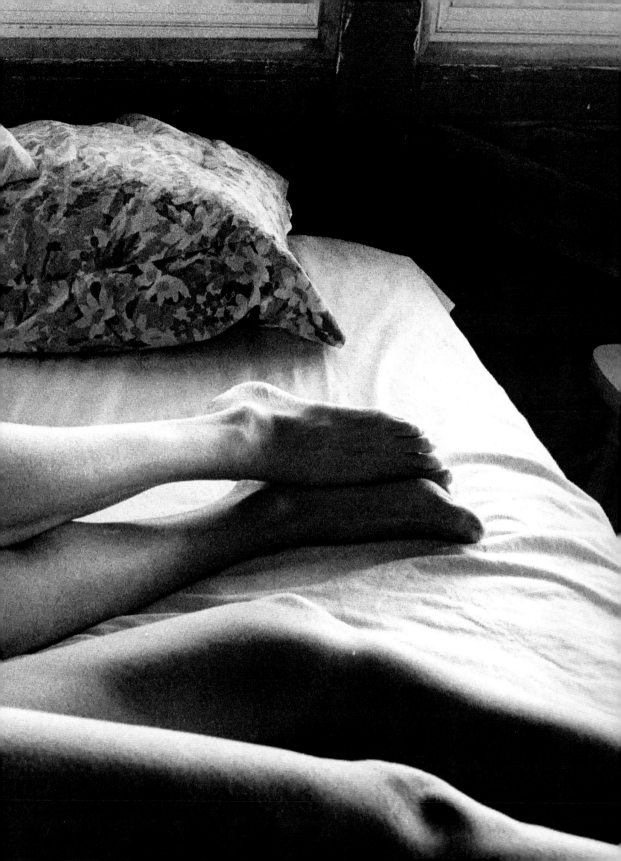

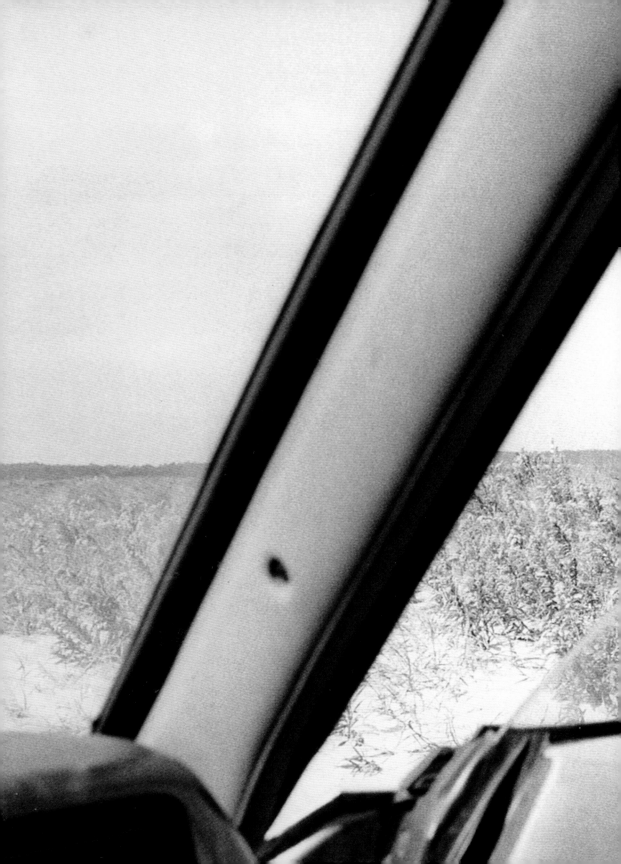

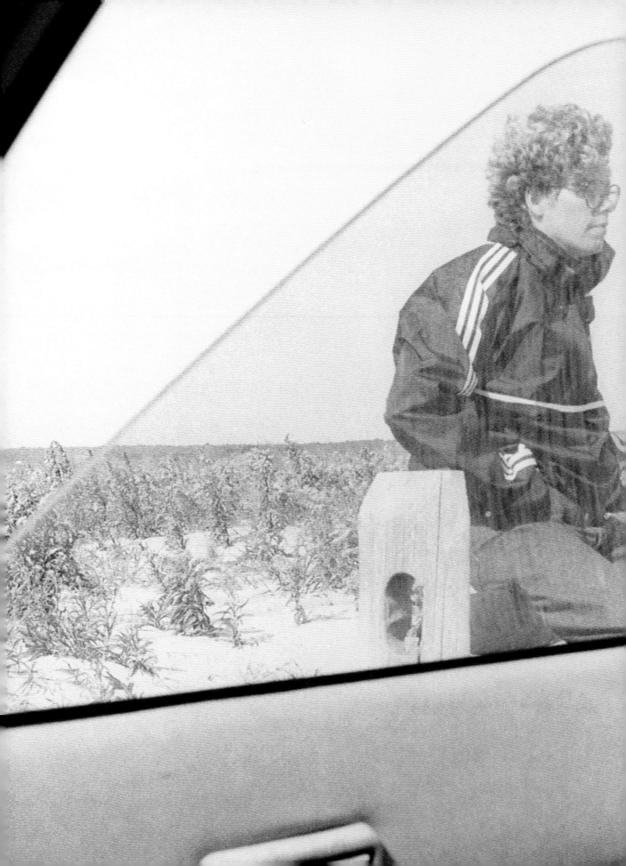

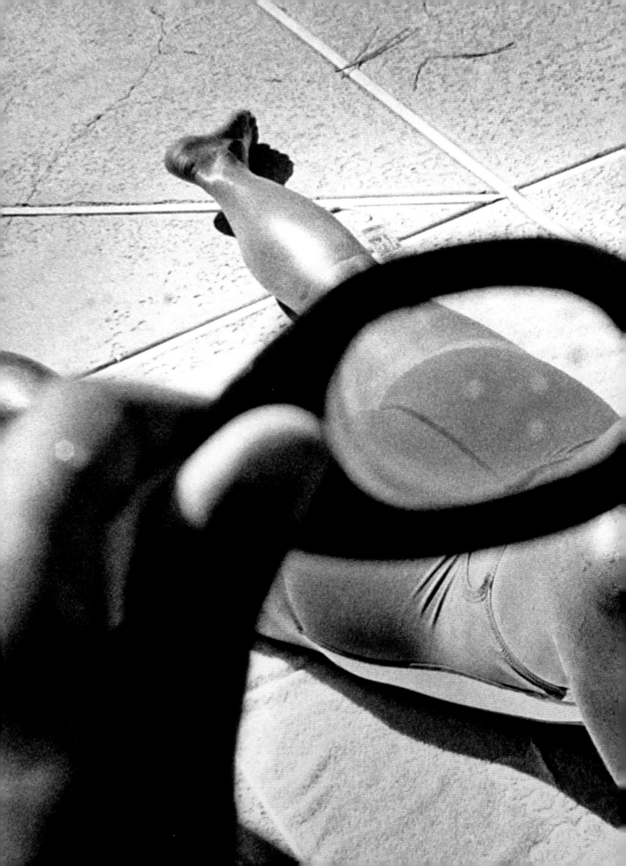

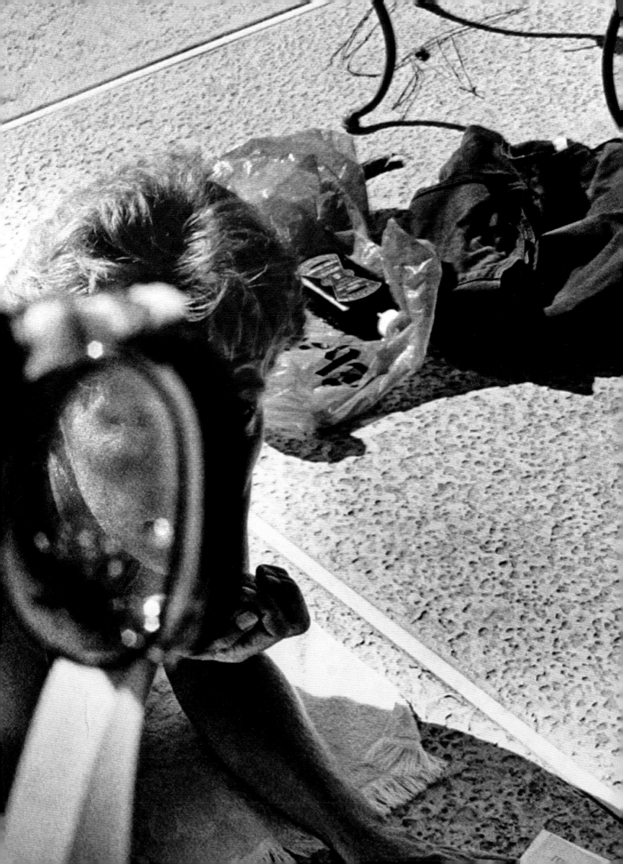

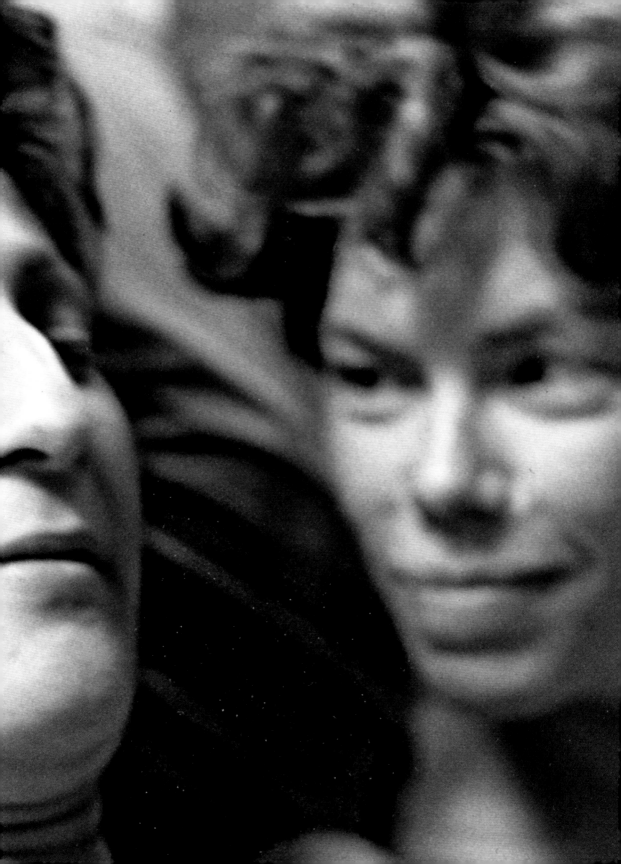

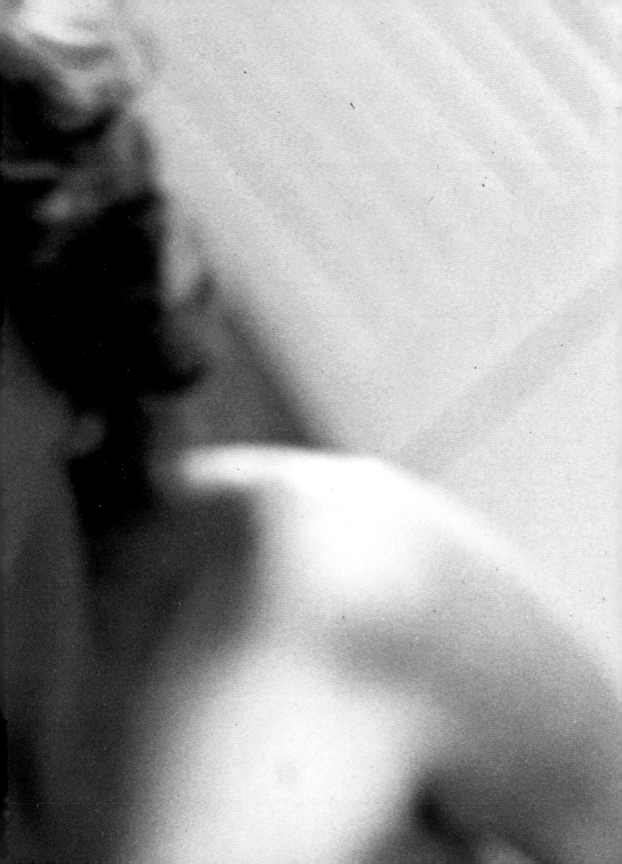

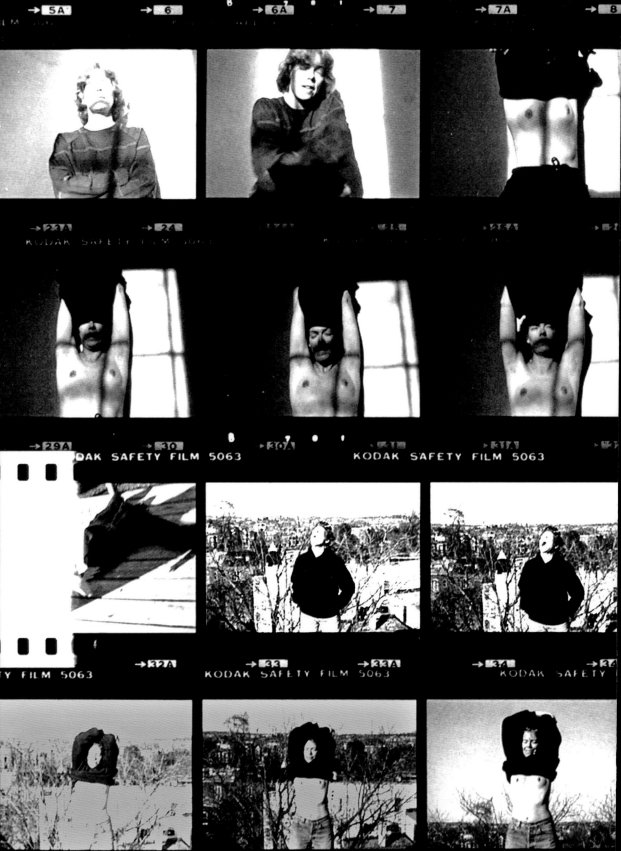

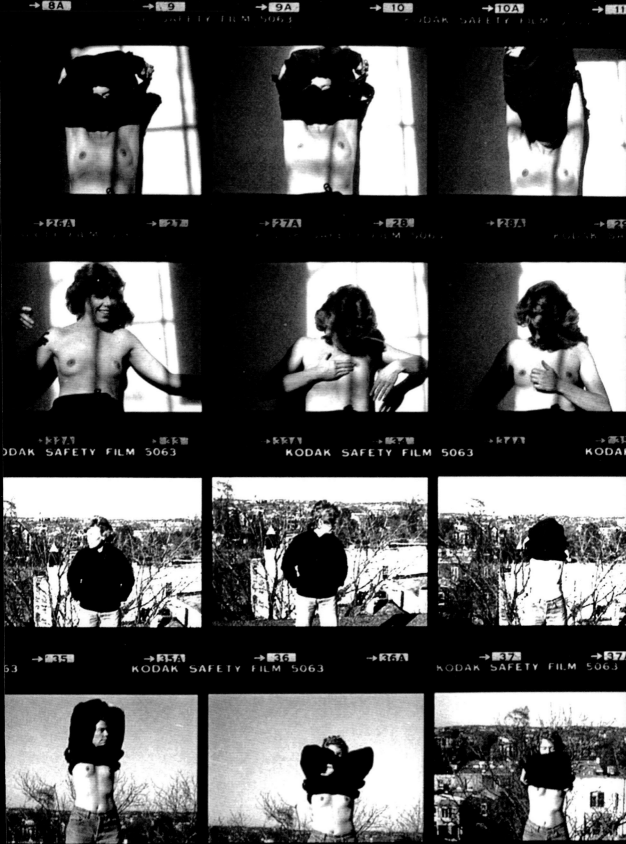

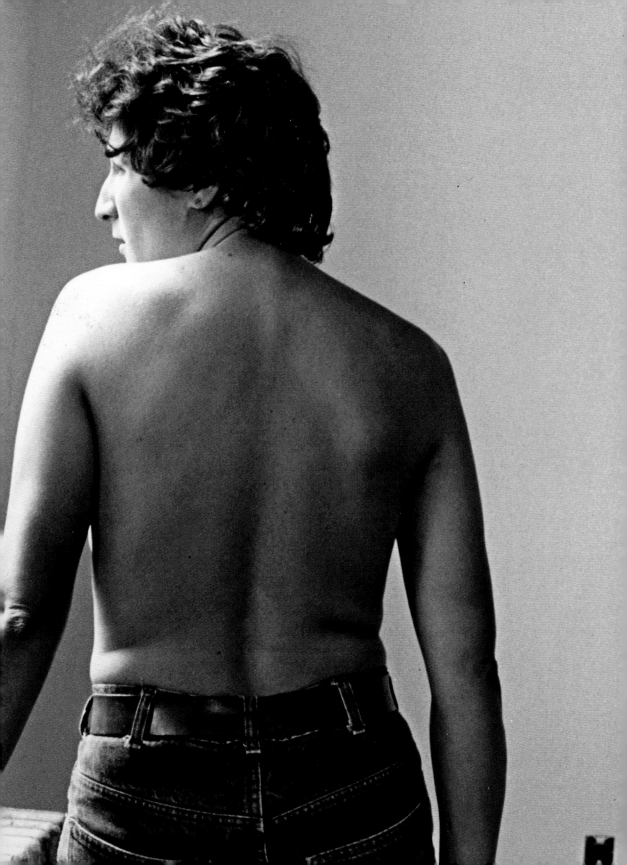

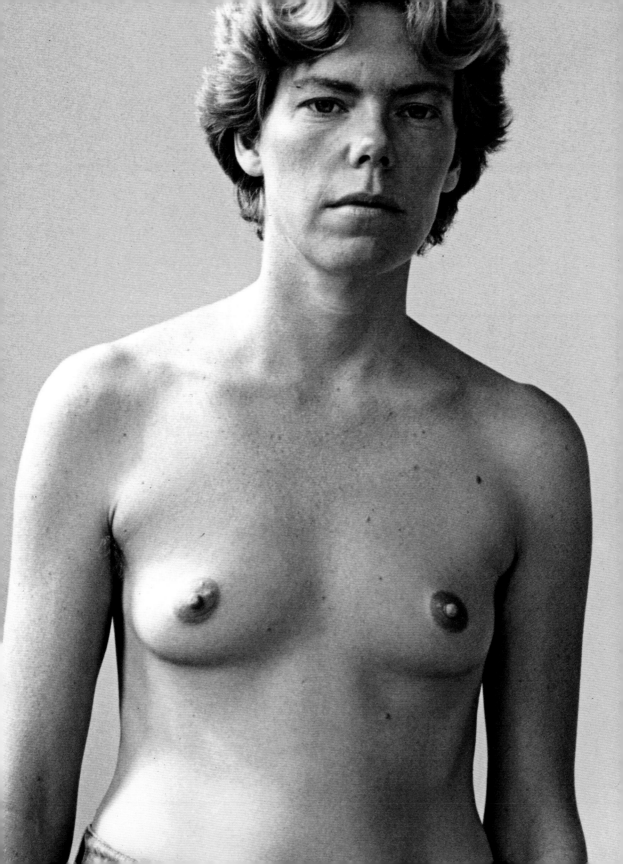

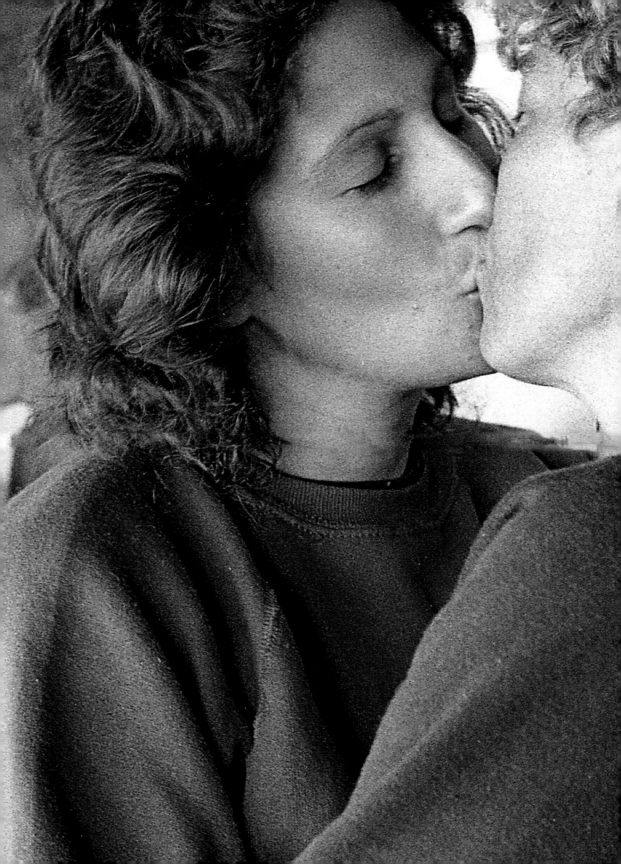

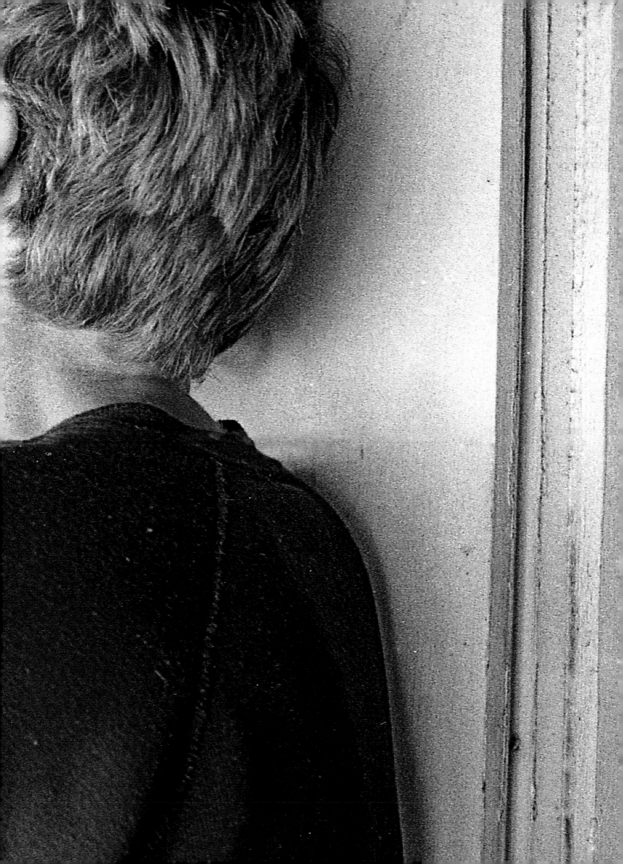

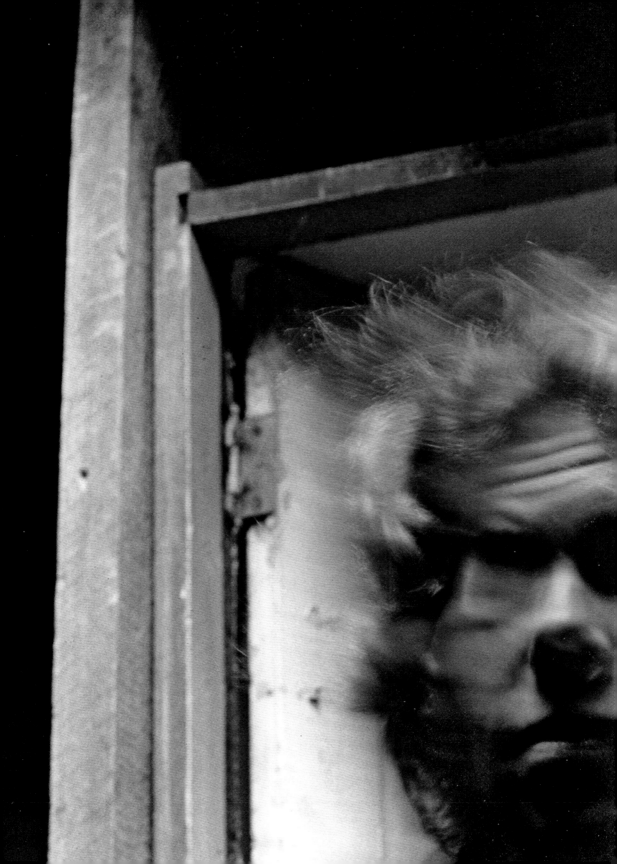

2-20-84

Dear Susan,

It feels to me like all the screaming
and crying is paying off. We seem to
be understanding each other's needs
better, and able to state our needs
more clearly to each other.

As we talk of ways to live together
again, under one roof, within the
same area code, it feels like a re-
newal of the committment that has
been growing between us.

When we are together it feels like
the right thing.

I love you,

Linda

6-12-84

Dear Susan,

There you are packing up our Washington
home. I'll miss the neighborhood, the
museums, the walks, and the American Cafe.

I'm thrilled with our new home. I'm so
excited that we found it together and that
we'll be living in it together all under one
roof. No Maryland House coffee or no waiting
for the Palmetto to arrive at Penn Station.

I love you,

Hinda

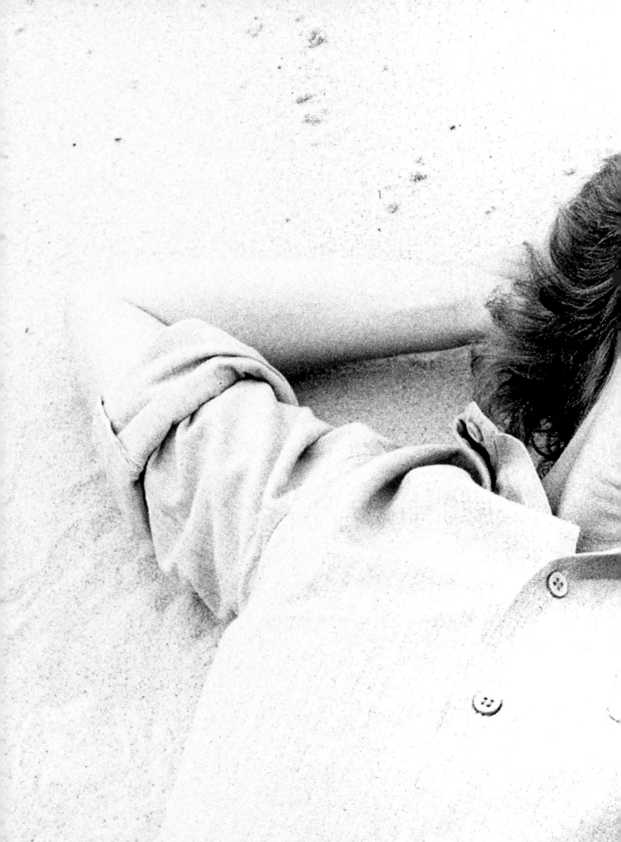

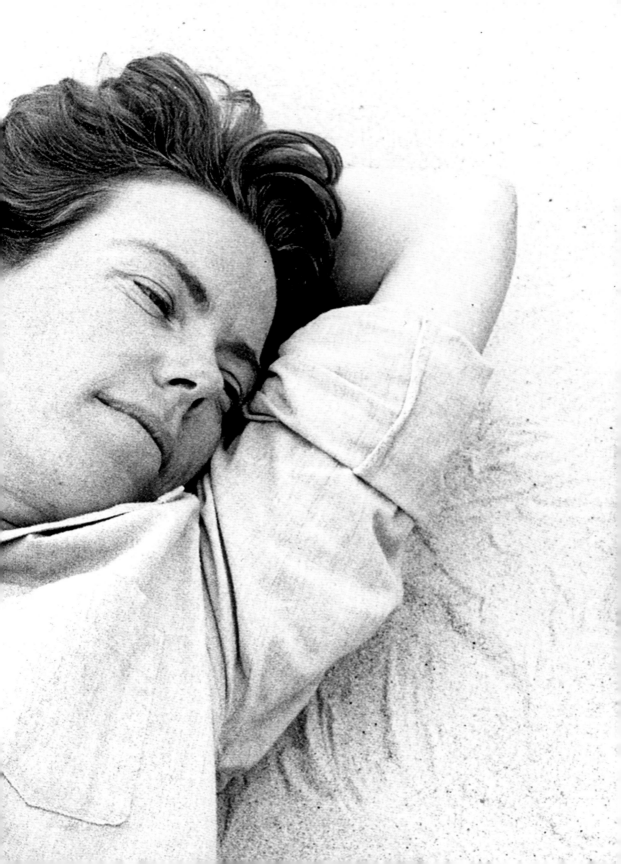

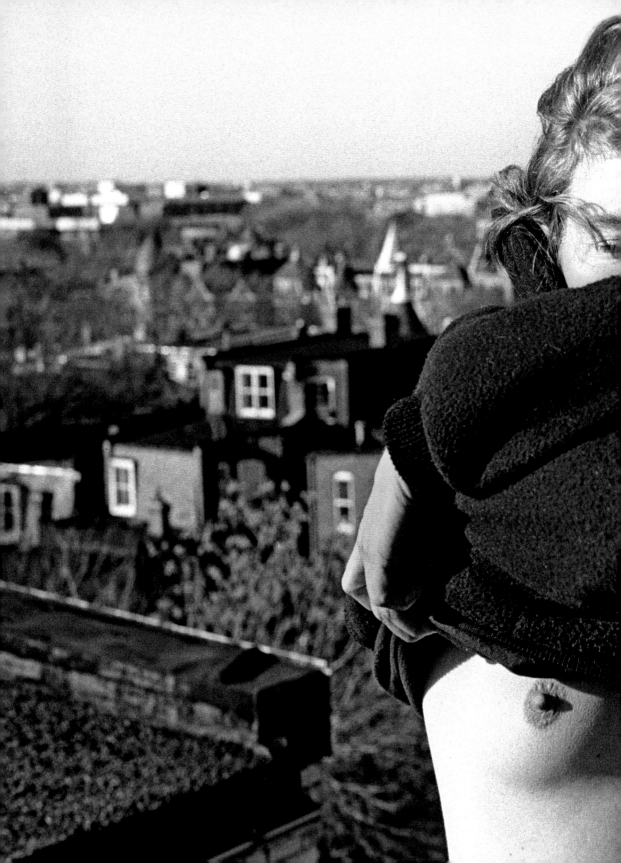

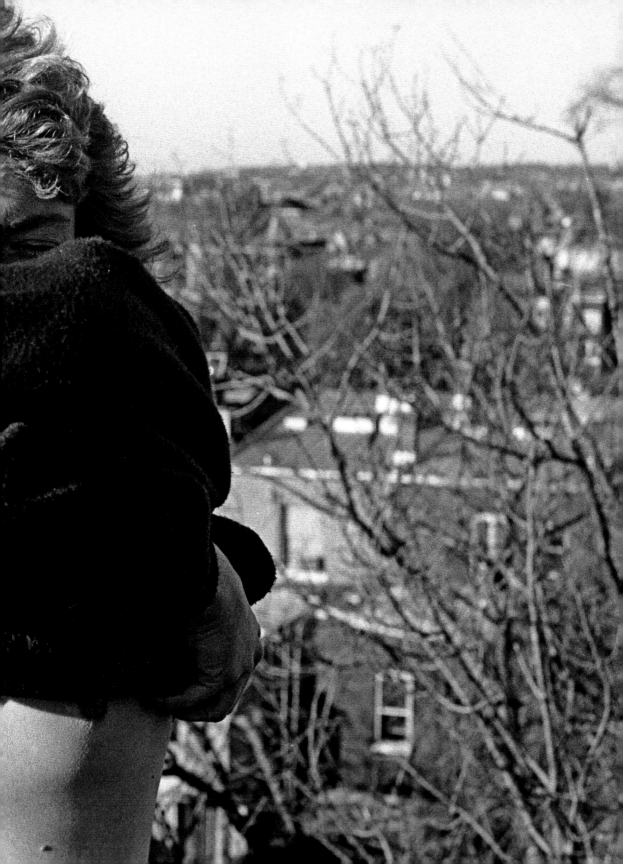

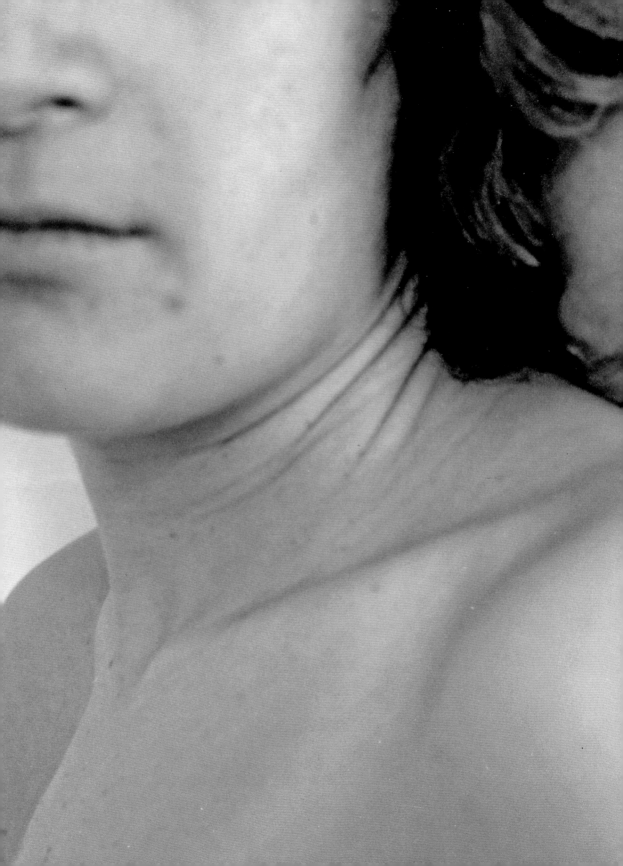

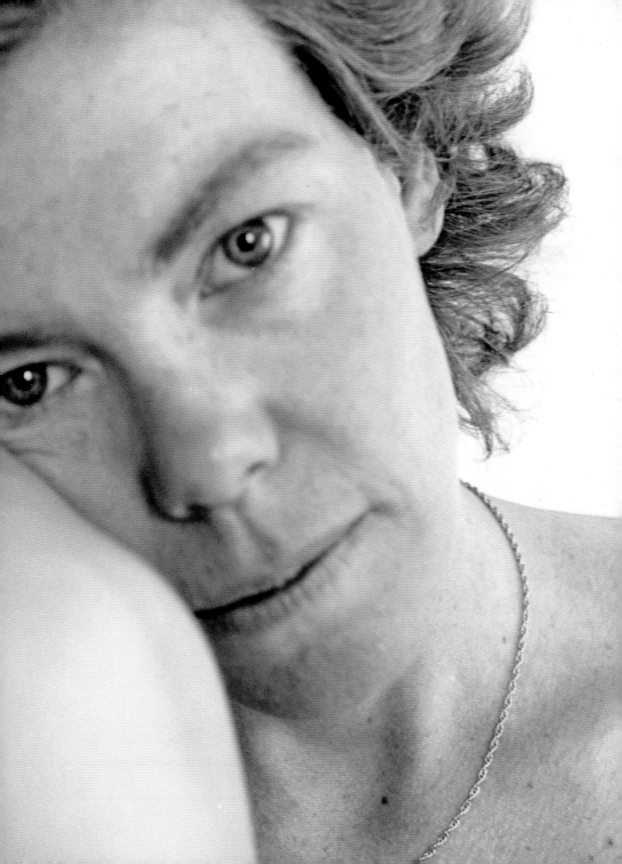

Summer 1988

Dear Shirley,

You'll never get this letter in the mail. My last letter to
you, written four years ago was never answered. I hear you
are happily re-married and that's all I know. Though I think
of you often, it is with sorrow for the loss of a wonderful
friendship. I don't really know why our friendship and
correspondence ended, though I have my hunches.

We were best friends. We worked well, and then could leave
work behind and enjoy each other's company. You helped me
and I helped you. We shared deep secrets and lots of
laughter. We played pranks and sat seriously in meetings.
I thought I'd be so lost when you moved, but we wrote and
visted and stayed in touch by telephone.

Then a funny thing happened. Jeremy left me for another
woman and I fell in love with another woman. I began to
tell you about her and show you pictures of her, and look
forward to the time when you would meet her. Then you
came for a visit and the three of us went to dinner and I
never saw you again, or heard from you again. I'd write,
and write and write, and there was no answer. So I gave up.

I've heard that when some people make big changes in their
lives their old friends can't accommodate those differences.
But I thought that we were different. I thought you'd be
delighted that I was un-depressed, un-stuck, happy, and
full of hope. I thought our friendship could continue,
and would continue. I wonder every so often if I might have
said something that offended you. But then you would have
answered my letters.

In some sense I lost a lot when I came out. I lost my role
as wife/householder/community leader. I lost money, and I
lost power. I lost friends and acquaintances. I became a
child to some, and stranger to others. But to me what I
gained is so great, so powerful, so important that the
losses pale in comparrison. Except for one. The loss of
my best friend. That's the one I haven't let go. At least
not completely. I guess I wonder what it is that you saw
that scared you, that drove you away? Your secret; my puzzle.

Love,

Hinda

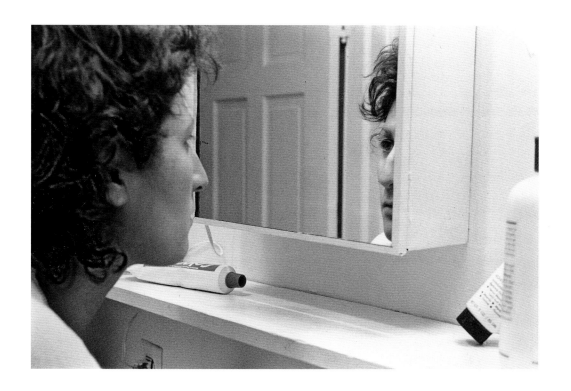

PART II
A True Story

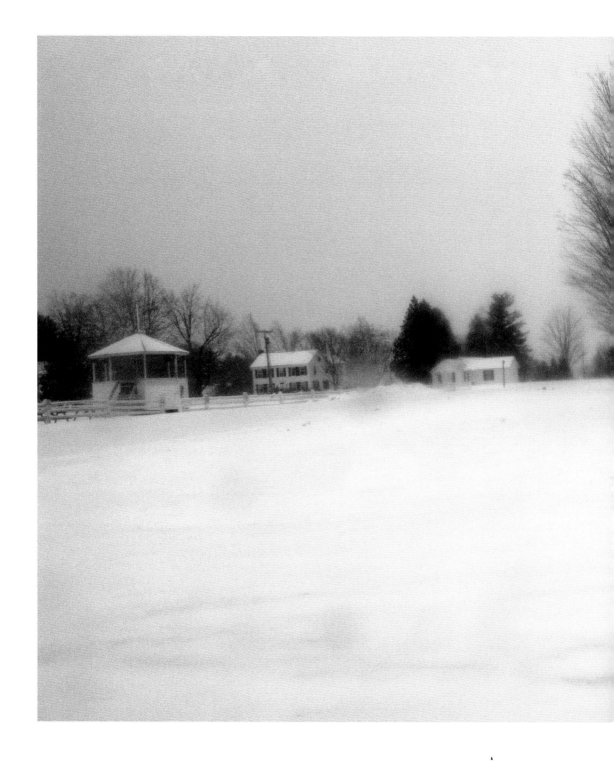

Vermont has always been about us coming together

and splitting apart.

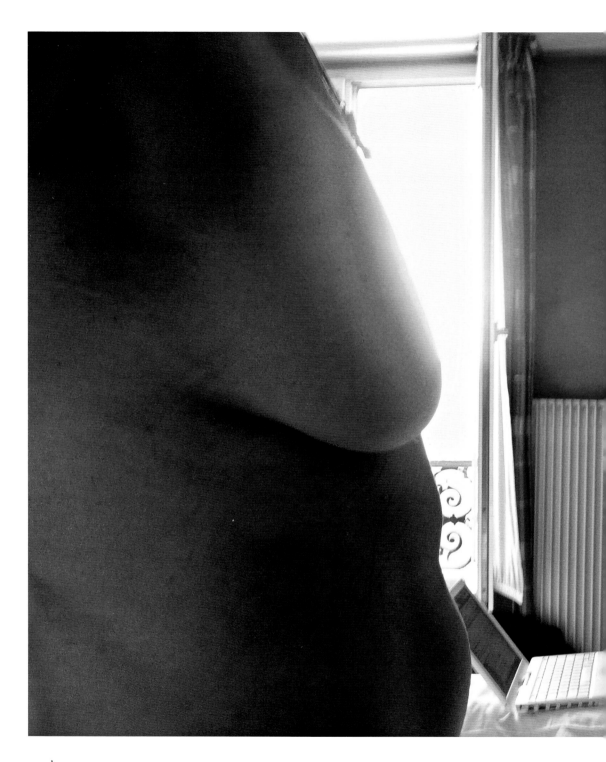

Yes, I was pissed.

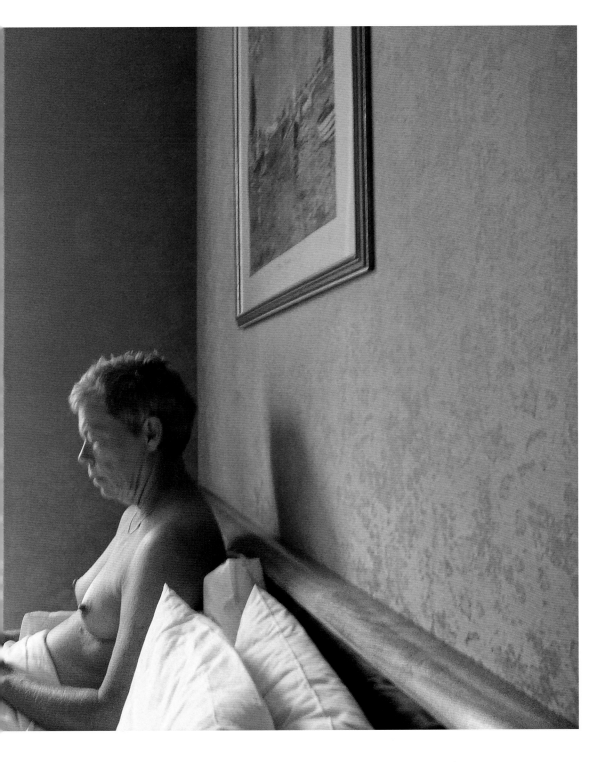

And I didn't want to be polite to you. And I wasn't.

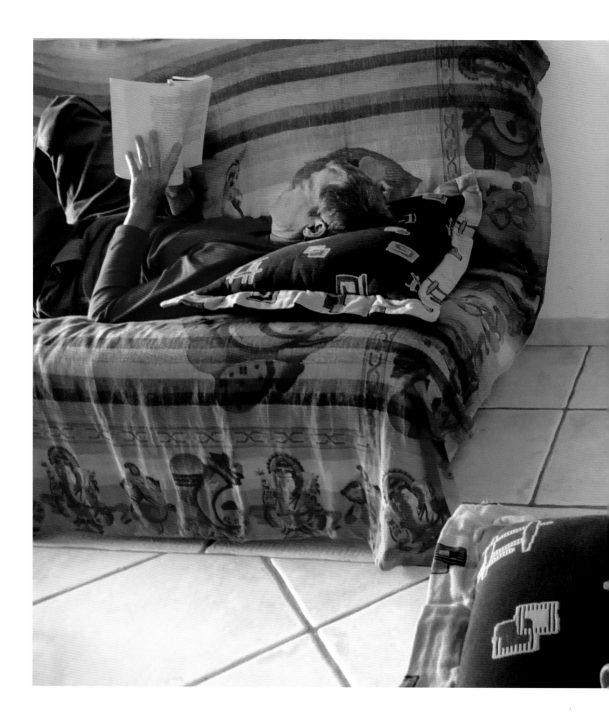

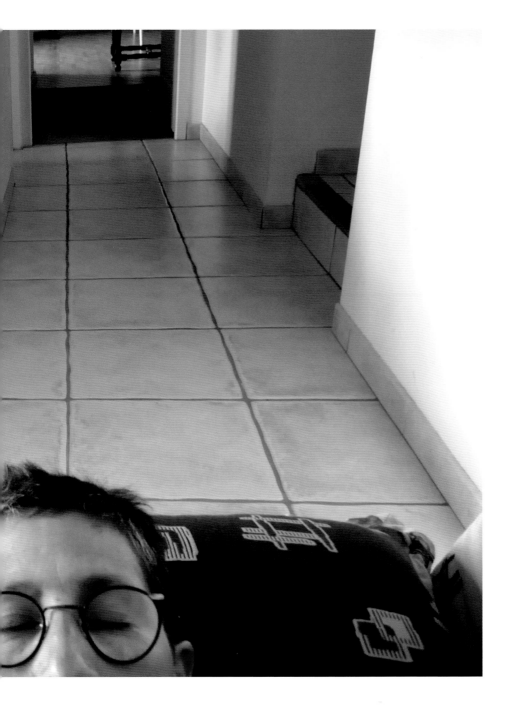

obviously, you cannot see
that both feelings can
exist at the same time

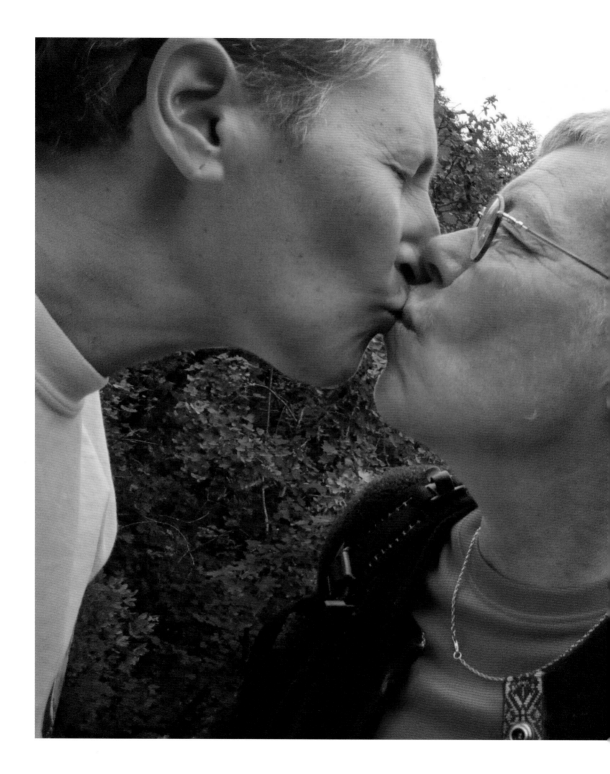

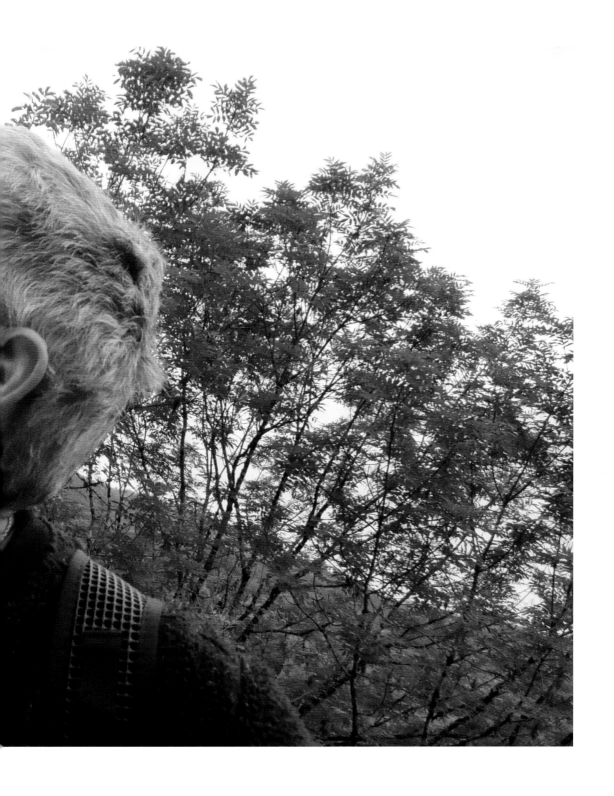

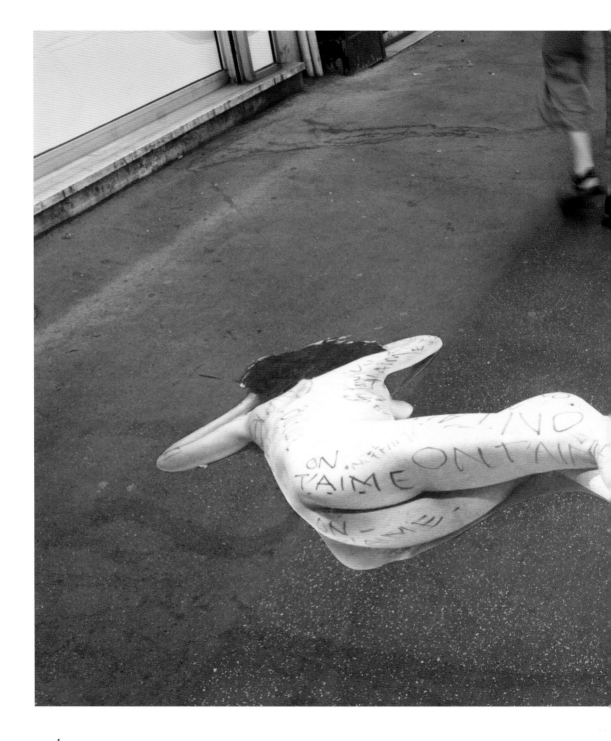

We are running away from
and towards each other simultaneously.

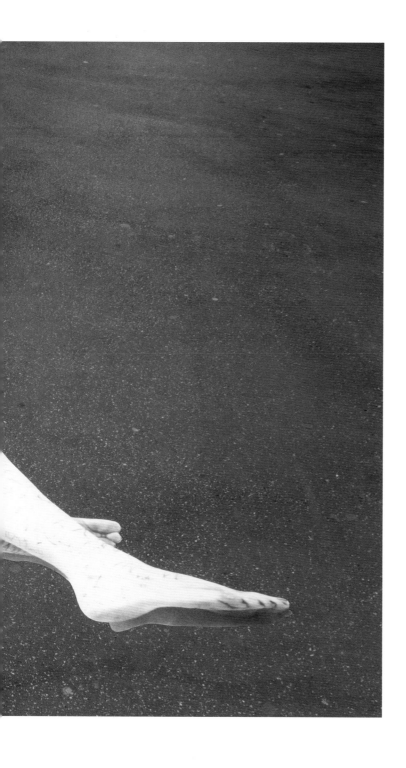

And it is making me crazy.

This really can not
work - we both thought
it could and you know
& I know
it can't.

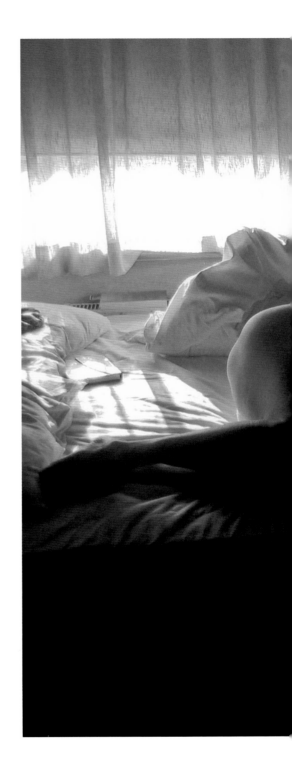

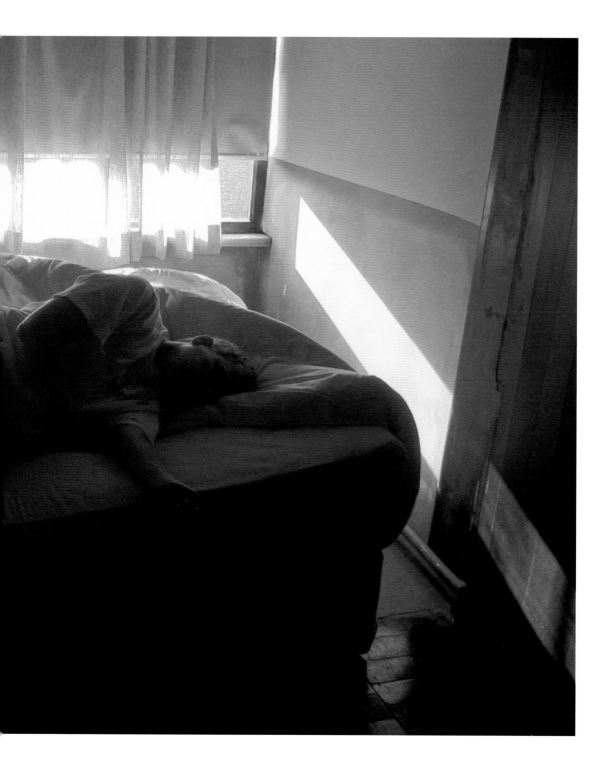

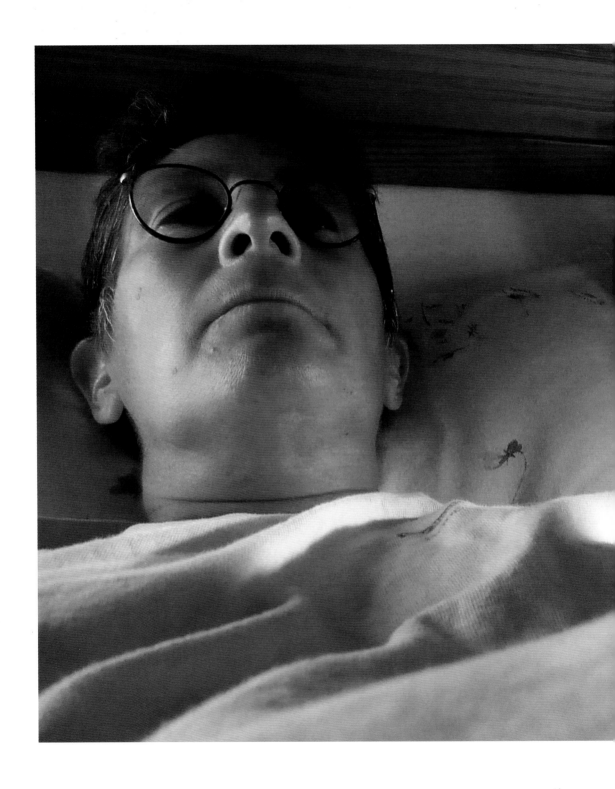

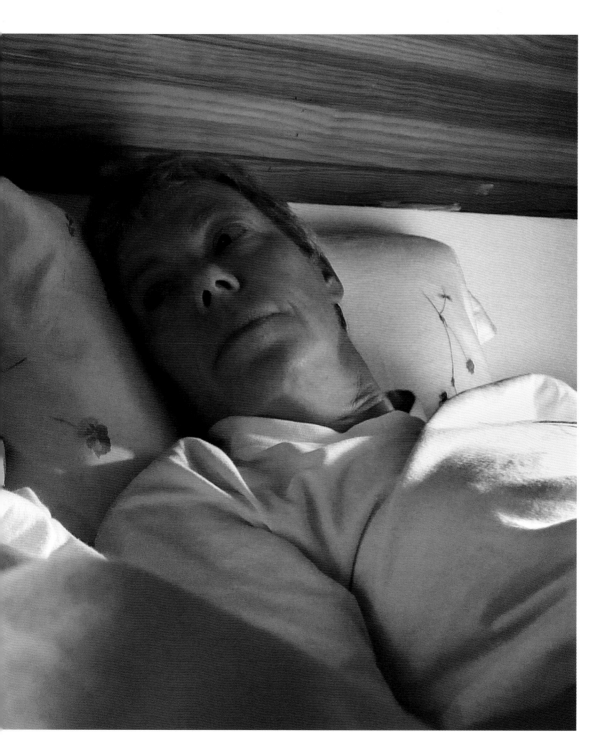

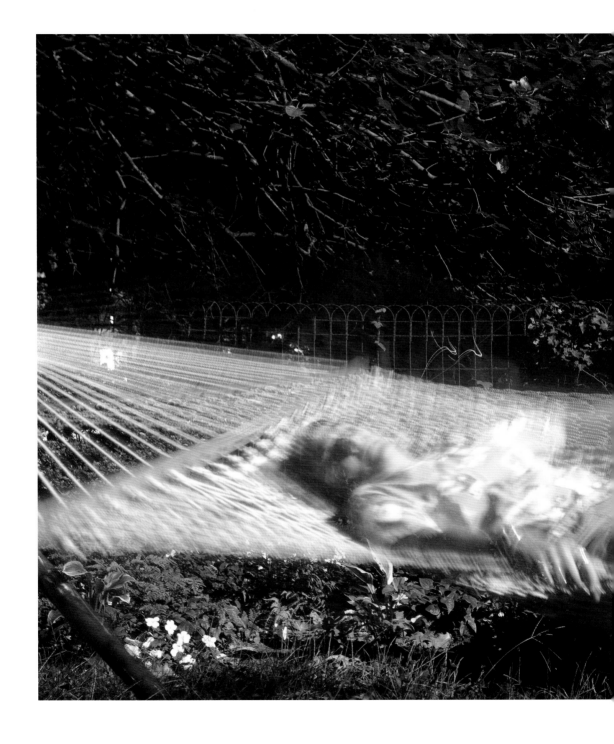

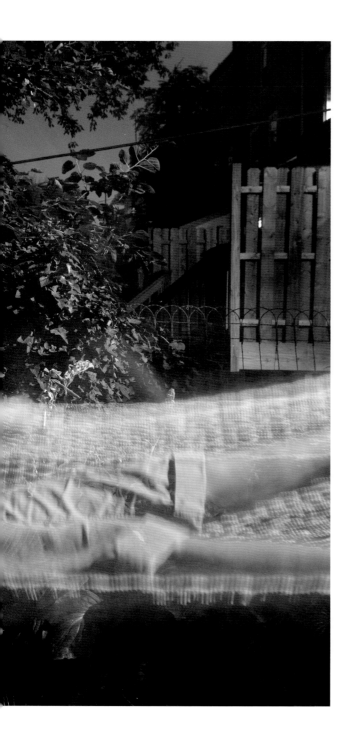

I was able to survive
your absence & busyness.
But not your indifference.

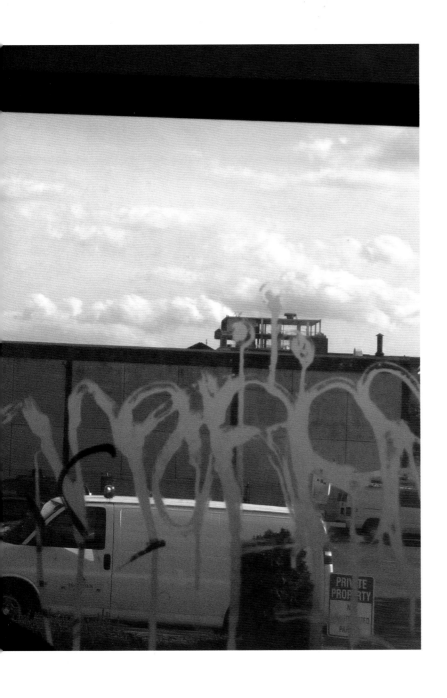

I need to be
by myself

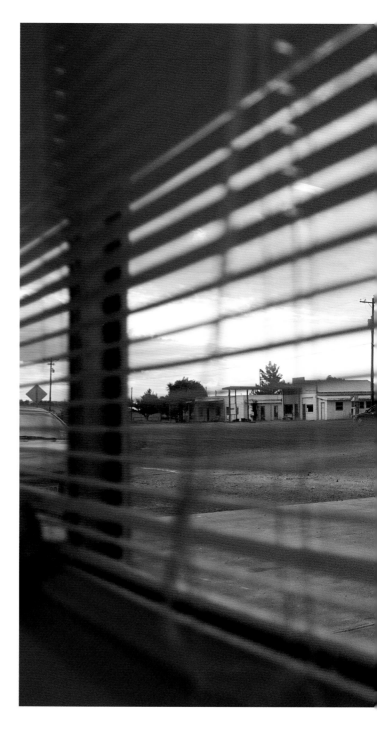

When we need to talk next time, I want
I want to meet in a public place.

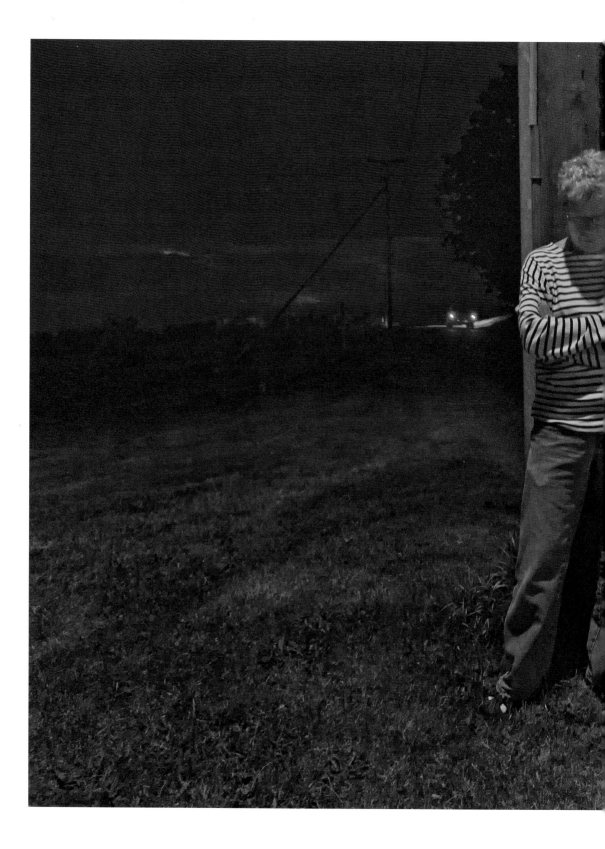

Just let me go.

I really cannot hear
from you anymore.

No. I do not have a lover.

We have nothing to lose
by separating.

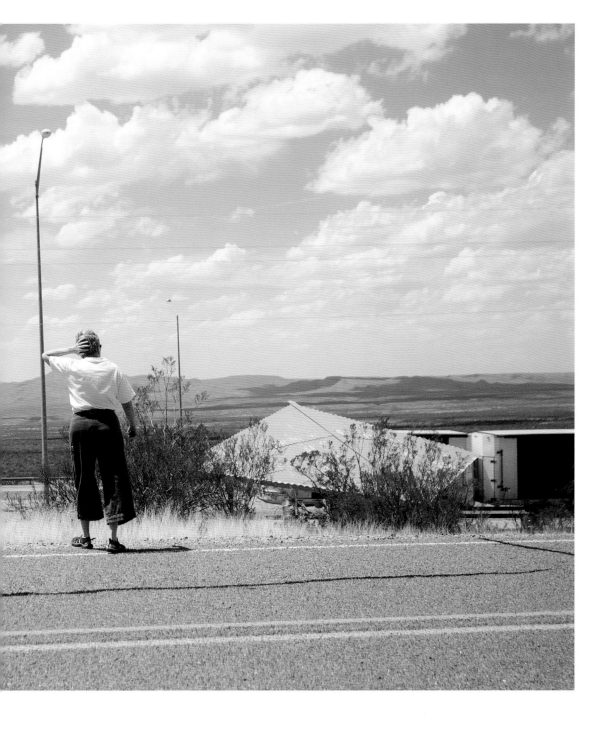

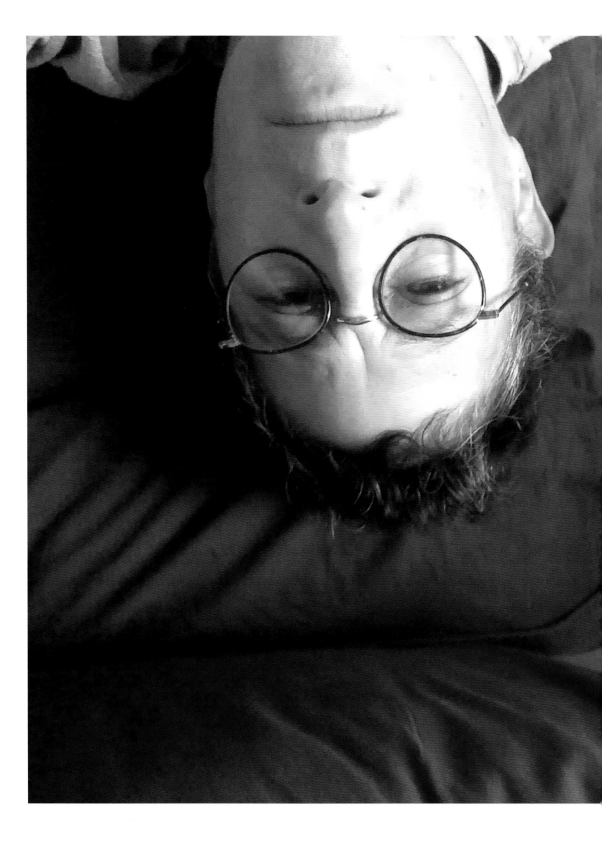

I had to fill out
an emergency
contact form for
a job. For contact
in case of emergency
I just froze.

So I wrote "911".

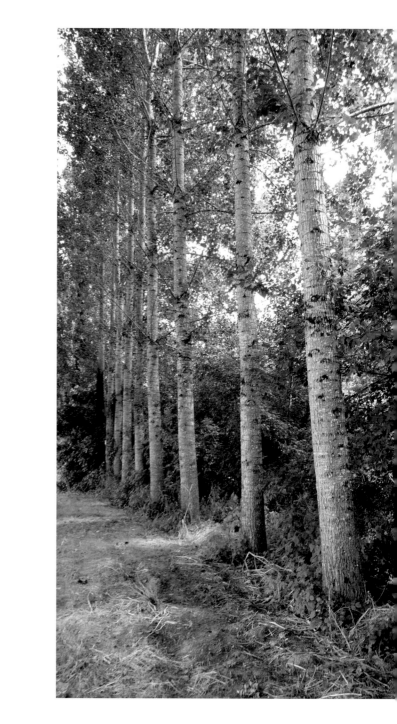

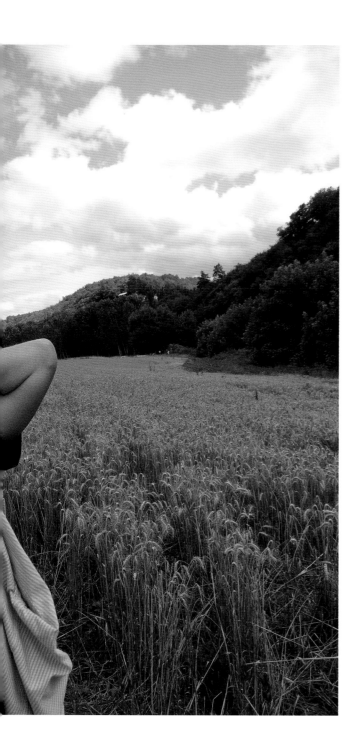

I am doing the best I can to get us untangled.

yet my feelings really haven't changed.

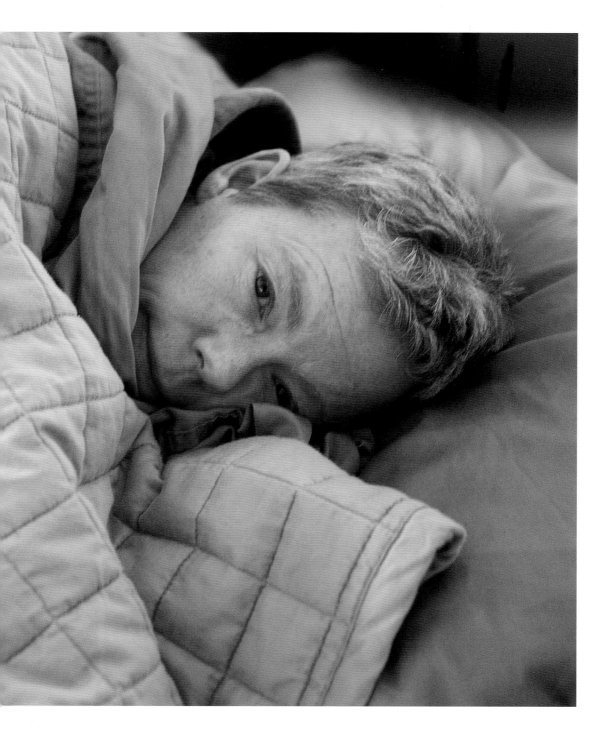

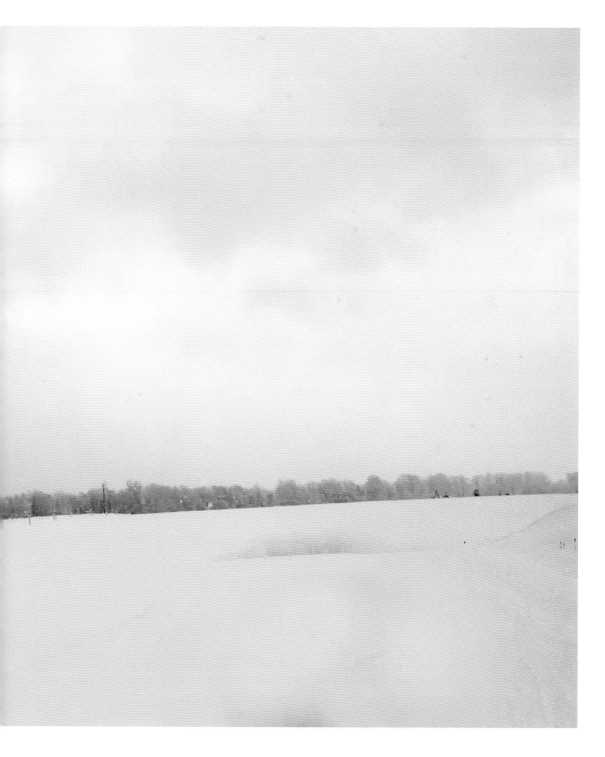

How could you just give up on this?

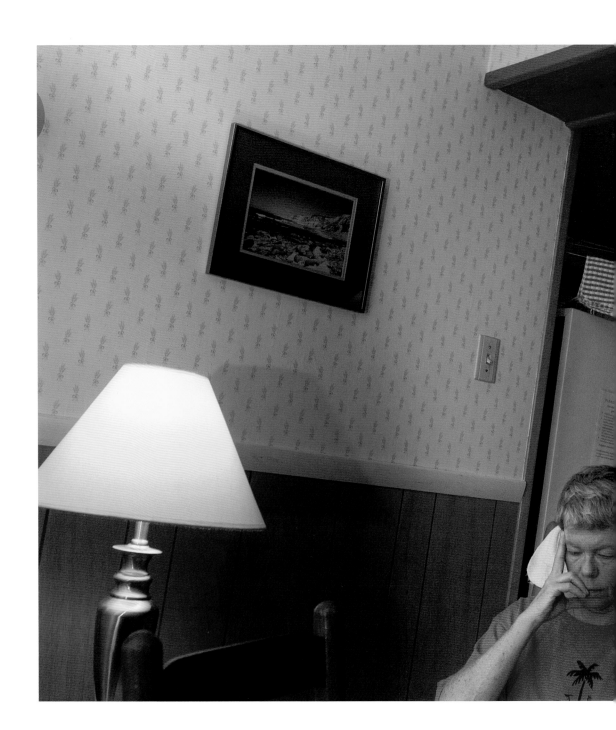

Can we stop the rehashing of these conversations?

This is not what
I wanted.

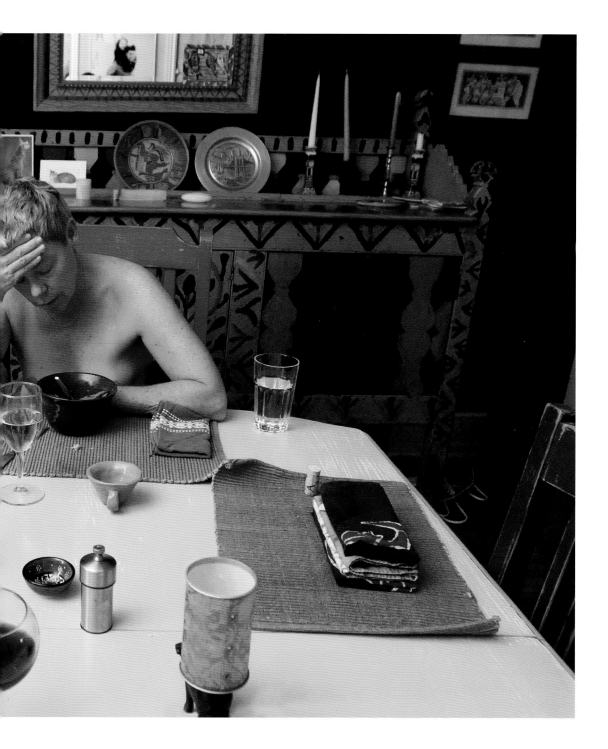

But I cannot and
I will not communicate with you.

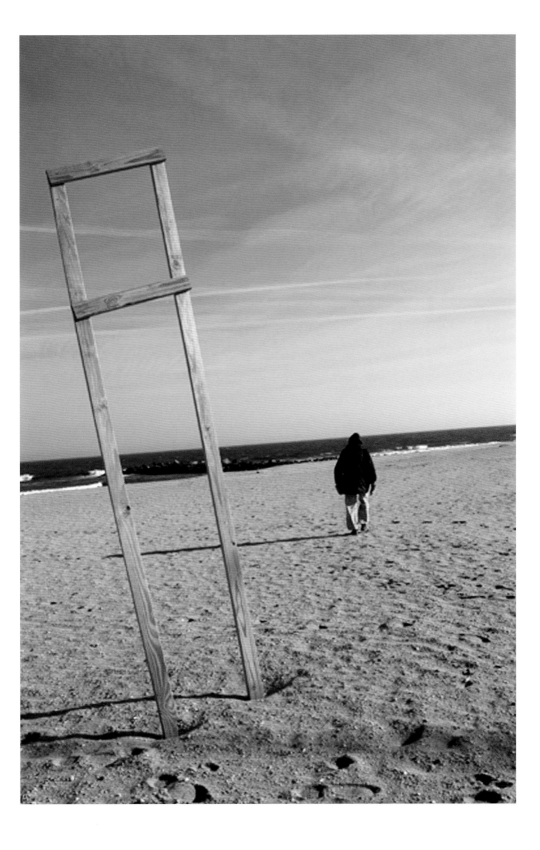

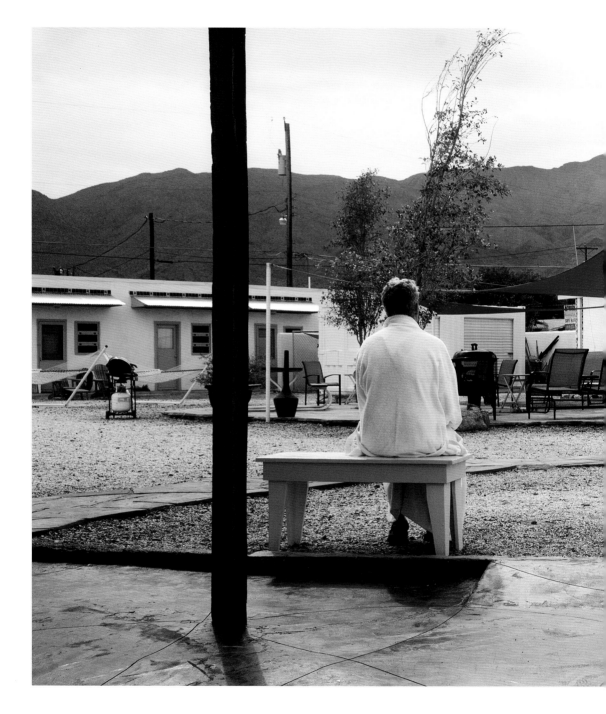

After I die, who will keep my ashes on their shelf?

This is a true story.

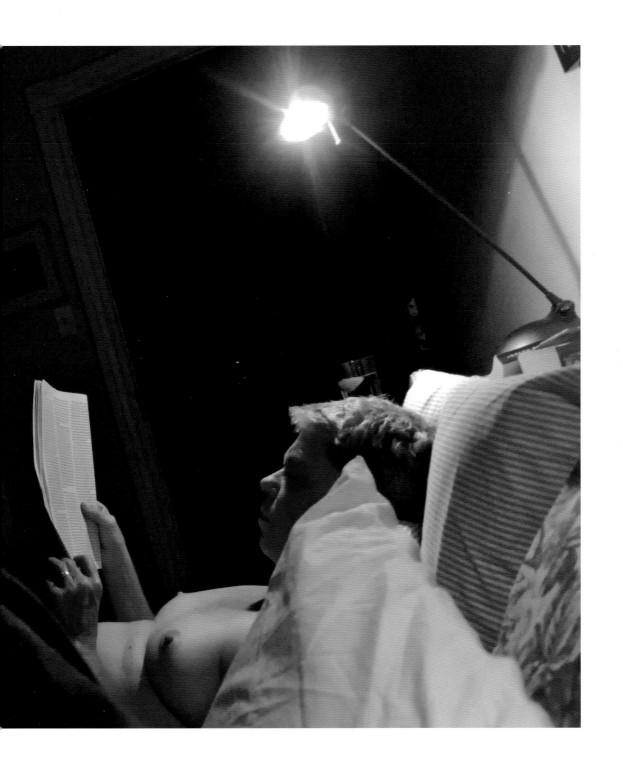

I have the photographs to prove it.

I came in and sat down on the love seat. Actually, It was a divorce seat. Susan was already on the couch. She and the counselor looked at me to begin.

I'm done. I can't do this any more. It's over.
We all avoided eye contact.

Biographies

Hinda Schuman was born in Brooklyn, New York, in 1948. She has lived in Philadelphia, Pennsylvania, since 1983. Schuman received an MFA from Tyler School of Art of Temple University in 1985. From 1988 to 2007, she was a staff photographer at *The Philadelphia Inquirer*.

Schuman's photographic work over the decades, including *Dear Shirley* and *A True Story*, has involved personal storytelling. Both projects have been exhibited in the United States and internationally. Other documentary photography projects include *Halfway Home*, about incarcerated women, exhibited at CCNY–Staten Island; and a series titled *Boxing*, about the fights, the gyms, the onlookers, and the fighters, which received a Fleisher Challenge Grant Award.

She currently teaches photography from her studio and at the University of the Arts in Philadelphia. Her work has been included in group shows and individual exhibitions. Individual images are in the collection of the Leslie-Lohman Museum of Gay and Lesbian Art in New York City. http://hindaschuman.net

Magdalena Solé is an award-winning social documentary photographer. She is known for her sensitive expressions of culture through distinctive color artistry. Solé's work touches on the themes of displacement and human suffering, societies living on the margins, and places forgotten or shunned by the mainstream. Her visual narratives are often inspired by poetry.

Solé's work has been shown internationally in more than 20 exhibitions, including 16 solo presentations. An important part of Solé's practice includes making limited-edition artist's books and photo books. Solé teaches photo workshops and lectures internationally on photography. Visual language has been her life's work, from graphic design as owner of studios in New York and San Francisco to her work in motion pictures. She graduated with a master of fine art in film from Columbia University. Her last film, *Man on Wire*, with Solé in the role of unit production manager, won an Academy Award in 2009.

Born in Spain, raised in Switzerland, she arrived in New York City in 1984, where she lived with her family for 30 years before moving to the deep countryside of Vermont. She speaks seven languages.

Sunil Gupta is a photographer, artist, educator, and curator currently enrolled in a doctoral program at the University of Westminster. Educated at the Royal College of Art, he has been involved with independent photography as a critical practice for many years, focusing on race, migration, and queer issues. His latest show (with Charan Singh), *Delhi: Communities of Belonging*, was at Sepia Eye in New York, and his most recent book, of the same name, was published by the New Press, New York, in 2016. His work has been seen in many important group shows, including *Paris-Delhi-Bombay* at the Pompidou Centre, Paris, 2011, and at the Tate, Liverpool, 2014. He is visiting professor at UCA, Farnham and visiting tutor at the Royal College of Art, London. He is lead curator for FotoFest 2018 Biennial, Houston, Texas. His work is in many private and public collections, including George Eastman House (Rochester, N.Y.), Tokyo Metropolitan Museum of Photography, Royal Ontario Museum, Tate Britain, Harvard University, and the Museum of Modern Art. www.sunilgupta.net

Acknowledgments

Many people have helped both me and this book come to realization. First and forever foremost is my wife, Susan Toler. She not only has been willing to appear in photographs throughout, and to share her side of the story, but also has supported me along the way to keep at it and not give up. Her presence in my life is powerful and loving. Her humor, wisdom, and empathy are powerful forces for our lives.

Giving me courage, love, and emotional support throughout has been Judith Lowenthal, to whom I am completely indebted. Linda Johnson is the unique friend who has both a critical eye for photography and a great heart, which buoyed me in some of the darkest hours of *A True Story*.

Letting me know the projects had merit are so many wonderful people—particularly Sunil Gupta and Magdalena Solé, who have been constant advisers and filled me with confidence and the warmth of real friendship. Sunil and I met in 1988 as presenters at a Society for Photographic Education Conference. Our topic: "Partners in Crime." Sunil is a visionary and a brave photographer whose constant work has fueled the LGBTQ communities across several continents.

Magdalena and I met when I signed up for a workshop she was leading. From my first phone call with her I knew she was a special person. I learned what a generous and superb photographer and educator she is as well.

Rebecca Michaels had the visual acuity to notice that I had left the tops off the diaries, and she helped with technical support on both projects—*Dear Shirley* in 1985 and *A True Story* in 2017.

I am also so thankful to Michael Itkoff and Daylight Books for having selected my story to be published. Their hard work, good thoughts, and support have been so affirming.

This book is also dedicated to my parents, Sonia and David. They loved broadly and acted wisely throughout their lives.

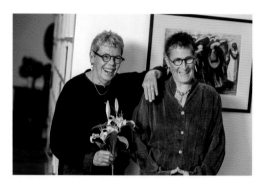

Photo: Johnny Milano

Hinda Schuman and Susan Gayle Toler were married Saturday in Brooklyn at the apartment of Thomas Halper and his wife, Marilyn Halper. Mr. Halper, who is a Universal Life minister and a cousin of Hinda, officiated.